From the Heart of the Country

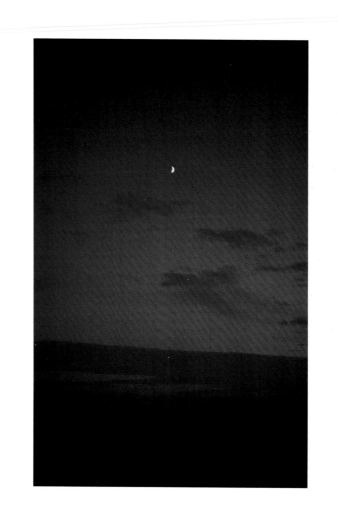

From the Heart of the Country

Photographs of the Midwestern Sky
by
Raymond Bial

Sagamore Publishing
Champaign, Illinois

Interior and cover design: Michelle R. Dressen

ISBN: 0-915611-41-4
Library of Congress Catalog Card Number: 90-64230

For Anna

Foreword

My mother's best friend from nursing school had a daughter my age. The girl was a St. Louis suburbanite who attended a Catholic girls' school. I was a farm kid, Protestant, played ball with the boys at the small rural school. We saw each other a weekend or two each year, and as we grew older we became more aware of, and interested in, our differences.

The summer we were fifteen we persuaded our parents to let us spend a week in each other's homes. I stayed with her family first. We visited an art museum and a department store, rode a city bus to the library, went to the airport and Sunday Mass, ate a Friday fish sandwich at White Castle—all new experiences for me. When she was to come to my home, I panicked. What could I possibly offer such a sophisticate? Her request was stunningly simple. She had never seen a sunrise or sunset, and she'd like to see one.

That request made a treasure of something I hadn't known I owned. The next two years I watched the sun as it rose and set (often from the school bus window), no longer just counting the days until I could grow up and get away, but beginning to realize that in doing so, I would leave something behind.

My friend saw several sunrises and sunsets that week, and was amazed to learn that the full moon rose when the sun went down. Years later I got a postcard from her saying that on her honeymoon she and her husband had watched the sun rise and set together. I no longer know how to contact her, but I've not forgotten what she gave me. I'd love to give her this book.

From the Heart of the Country has an effect similar to my friend's request. It gives a great value to something so common to some of us that we might not realize we have it. For others it captures something wonderfully unfamiliar. Raymond Bial's photographs often do that. Previously he has turned his lens to small town inhabitants, their rockers still on the porch, canning jars set on the window sill, hay rakes left in the weeds. Each time he shows us a beauty overlooked or unsuspected, something valuable we might take for granted.

Bial's aesthetic is firmly rooted in soil, in regionalism, in realism. We've even joked that he doesn't do "art" because you can always tell what he has photographed. He continues to look his subject in the face, yet his approach is neighborly. He doesn't condescend to subject or audience.

Bial's earlier books of photographs are in black and white, a medium in which he excels. When he told me a couple of years back that he was beginning to work in color, I teased him about losing his innocence, his purity. Ray assured me that his use of color did not mean that he would be doing "postcard photographs." Indeed, it did not. There is no loss of integrity in these photographs.

When Bial's camera is loaded with color film and raised above the flat ground, you no longer see the body of the Midwest, but its soul. There is a transcendent quality in these photographs that emerges from some source other than the subject itself. Perhaps, just as we best understand Biblical shepherds by looking in wonder at the winter night sky, we feel closest to the settlers in the Midwest by seeing the sun rise and

set over the plains as they would have. We see a ruled line of heavy clouds, flames in the air, the crescent moon as though they were new.

But we also see in Bial's images the artifacts of this century. He doesn't avoid the contrails or powerlines, now naturalized elements of the midwestern landscape. Cemeteries and hedgerows don't apologize for their presence. Farm houses, barns, and grain bins are not intruders between us and sky; they extend us, defining our place.

From the Heart of the Country has the magic to extend us, to make a new or remembered place for acting out our lives. It is a place that gives us room for larger gestures. Momentarily, at least, we can transcend the hedgerows of our lives.

—Kathryn Kerr

Preface

Lately, I have introduced my daughter, Anna, to the experience of photography. We have been concerned not so much with technique as with the spirit of the art form. We drive out into the country in the evenings, just as the light begins to decline, to observe the subtleties of the sky. We are allowed just a few minutes before the sun eases over the rim of the earth. During this brief interval, we stand enclosed within a distinct mood, hoping to capture a portion of it within the rectangles of our photographs before we are overtaken by night.

At dawn the experience is reversed. Rising in the absolute dark, I collect my equipment and film, and go forth alone. Initially, the only light is that which streams from the headlamps of the car. Stopping at the edge of the road, I set up my camera and point the lens toward the first light seeping over the horizon. Sometimes I can hardly see my hands, let alone the parts of the camera. Gradually the black dissolves, as if by some atmospheric metamorphosis. Initially, I am able to distinguish only the vague outlines of familiar forms—corn leaves dulled by road dust, the angles of a barn roof, the shimmer of the asphalt on the road before me. Colors slowly rise to the surface of what was moments before a completely grey landscape.

If the various elements of weather happen to be favorable, I am presented with a few minutes of intricate light and color. Without looking directly at it, I observe the sun rising, a deep fuschia through the mist, or a liquid red against the broken clouds.

When Anna and I go out in the evenings, we are offered only a few minutes of perfect light. However, during these ephemeral moments, we can turn a circle of the sky and photograph not only directly into the sun, but in any direction in which color may appear in the distant atmosphere. Often our finest photographs are made after the sun has completely gone down.

At dusk, the color is fast replaced by the finality of dark, whereas at dawn I am often presented with the best possibilities for photographs well before the sun eases over the horizon. Once the sun is fully above ground, the delicate qualities are lost as the light quickly sets into the hard reality of another day. The soil absorbs this light so that it appears blacker than black, farmhouses begin to glisten white, early light flashing off their windows, and the corn radiates green.

There are, of course, many appealing qualities to the midwestern landscape throughout the day, especially if you follow the seasons. Through the winter the bare ground is routinely black, occasionally brightened with snow. During the spring the trees are briefly transformed by a delicate lacework, and thin lines of green begin to emerge in every field. By early summer the land becomes thoroughly quilted with green, this single color with little variation unfolding to the bottom edges of the sky. Finally, in the autumn, the corn dies back to beige and the soybeans wither into rust-colored shades. All else, principally the milkweed, Queen Anne's lace, chicory, and other weeds and flowers growing on the margins of fields and roads,

also eases into various shades of brown.

Only the woods scattered like so many islands across the plains manifest the stereotypic autumn foliage. Yet the change to brown in the fields is both jarring and lovely, a welcome relief from the monotonous green of summer and the ponderous blacks and greys of winter.

All of the photographs in *From the Heart of the Country* were made during the plains' best moments, that is, quite literally, at either end of the day. In the quiet of first light, shadows stream like ribbons across the land, and the sky is fired with a complement of colors emerging from the atmosphere itself. A similar event occurs in the sky at dusk when rose, orange, and purple burn forth from the deepest shadows.

The photographs in *From the Heart of the Country* are also intended to embody a sense of space. To many people, the Midwest is a broad, parsimonious landscape. Yet I am most often exhilarated by the plains unraveling before the eye, broken only by telephone lines stitched across the sky and occasional farms seeming to be always in the distance. Such great distances lie between objects, whether architecture or natural forms, that the open spaces have a presence of their own, often with more substance than the houses and elevators and other human-made objects.

The more you study the midwestern landscape, the more you realize that this sense of space is due primarily to the predominance of sky. It looms over the land, softening its hills, at times even flattening it, and boldly displaying its weather. In fact, because of the sky, the weather is always upon you,

making you a part of its events. During a storm, my younger daughter, Sarah, reports that the thunder is going in her ears, and she fears that the lightning will come into the house.

Out here the wind never relaxes. Storms brew, clear days are more than obvious, and the porous blue of the sky rises amazingly high. At midday the sun bleaches out colors and so diminishes shadows that they seem to vanish within themselves. You have to go around squinting through the road dust and the brilliant white light, the wind in your face.

The photographs for this book have been made in all varieties of weather. Some were made on crystal clear mornings, others when clouds lingered in the distance. Many of the photographs were made during autumn and spring, when the sky is most volatile. Yet, in every instance, the photographs were made at first light and at dusk.

I am introducing Anna to photography at dusk (and I hope someday at daybreak, as well) not only because of the quality of light, but because these times embody the cycle of life. You quickly learn that you really cannot make photographs. You simply let them happen to you. As you learn to accept what light you are given on any particular day, you become aware of your small place in the universe. As the orange wafer of the sun descends, you realize that what you are experiencing is the earth moving beneath your feet. Just as the days and the years turn in a circle, so do the generations. Someday Anna may be standing at the edge of a country road, remembering her father, while teaching her own child the art of photography, along with an appreciation for that which is lovely on this planet.

—Raymond Bial

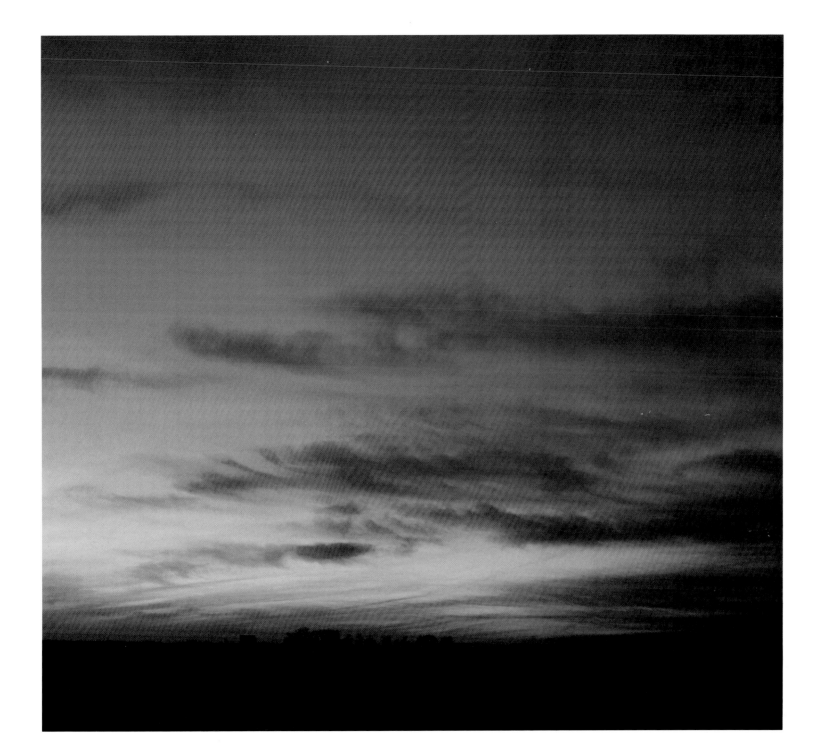

11

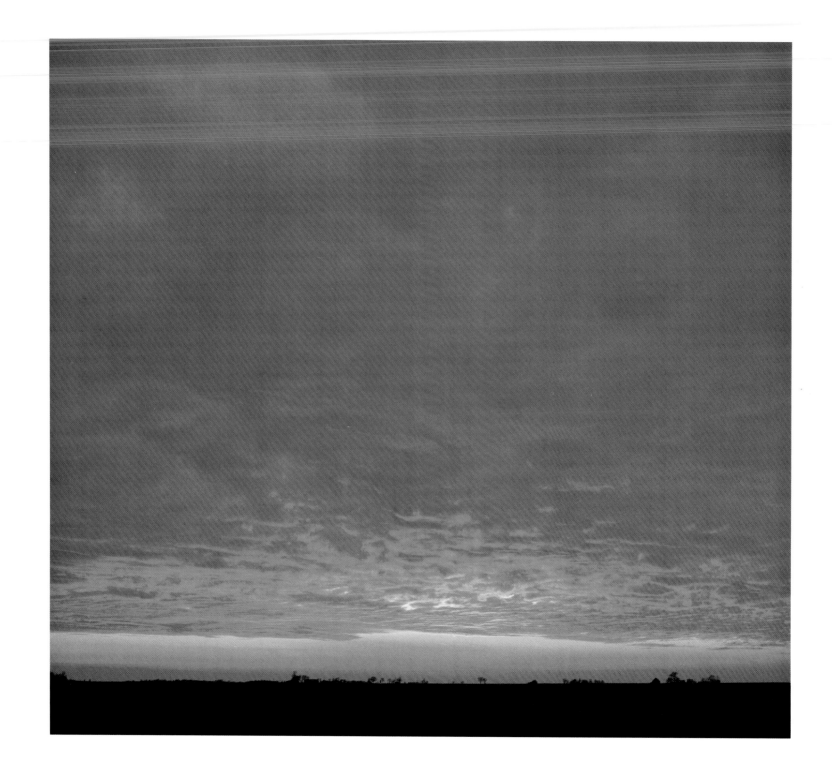

12

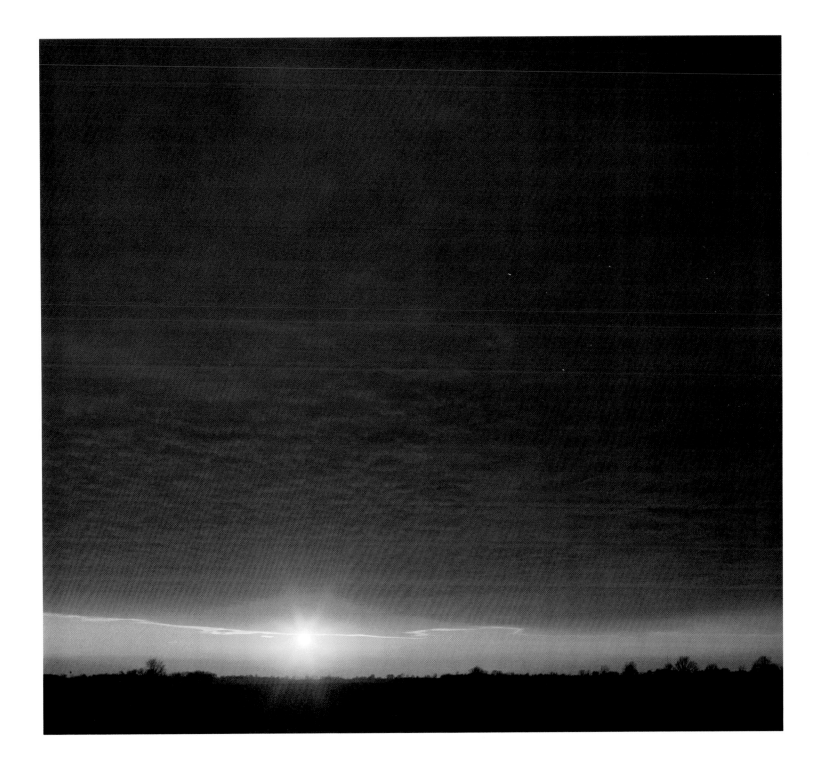

13

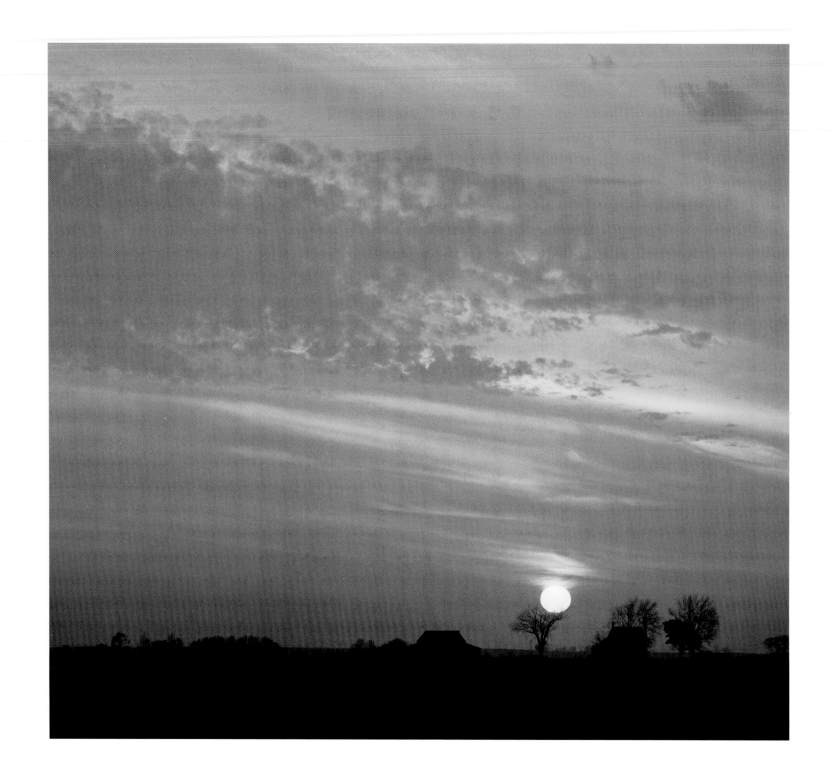

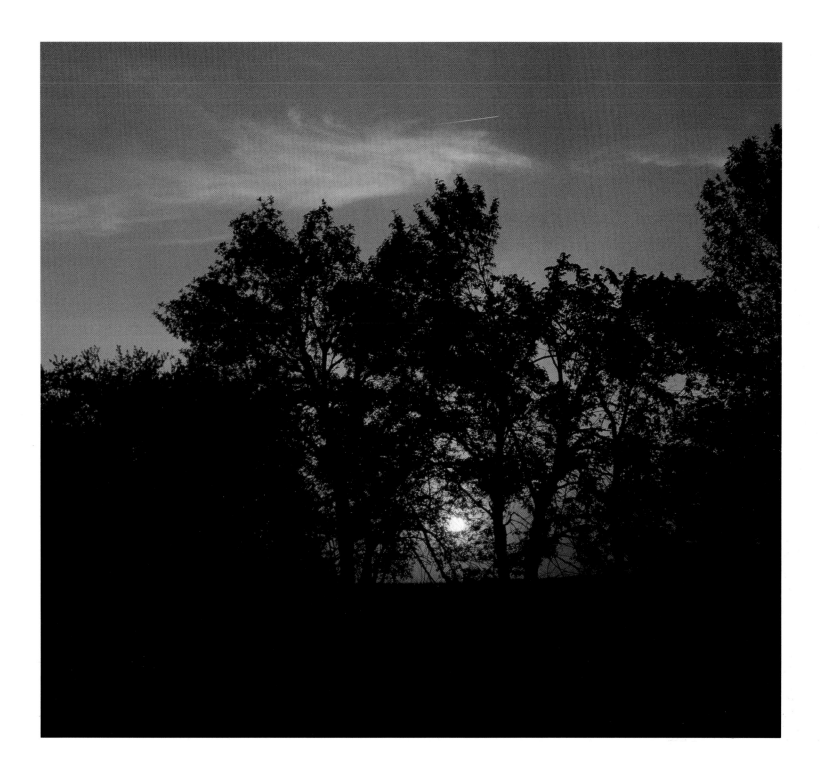

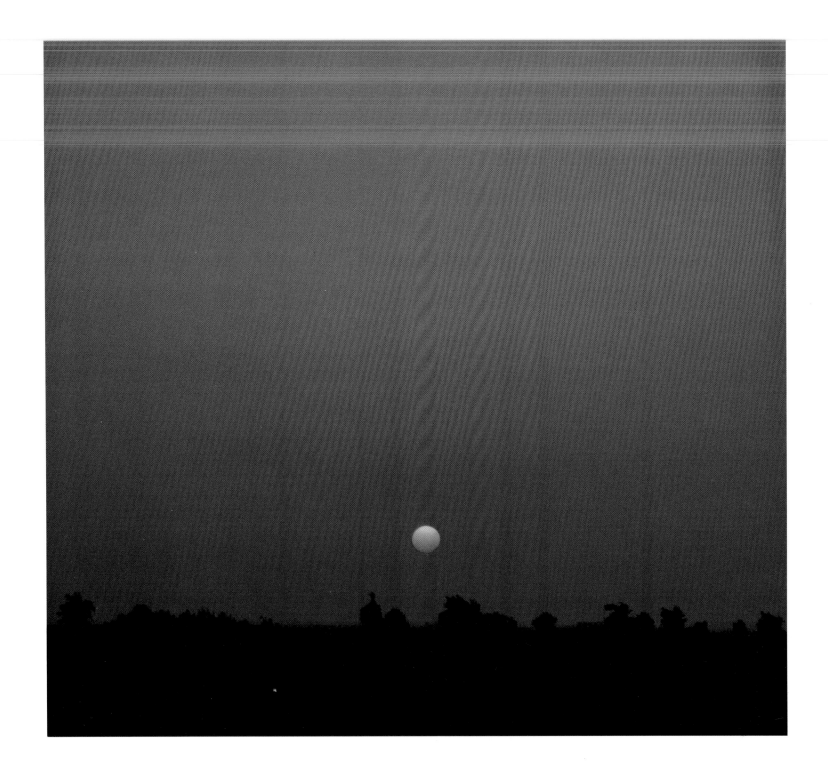

16

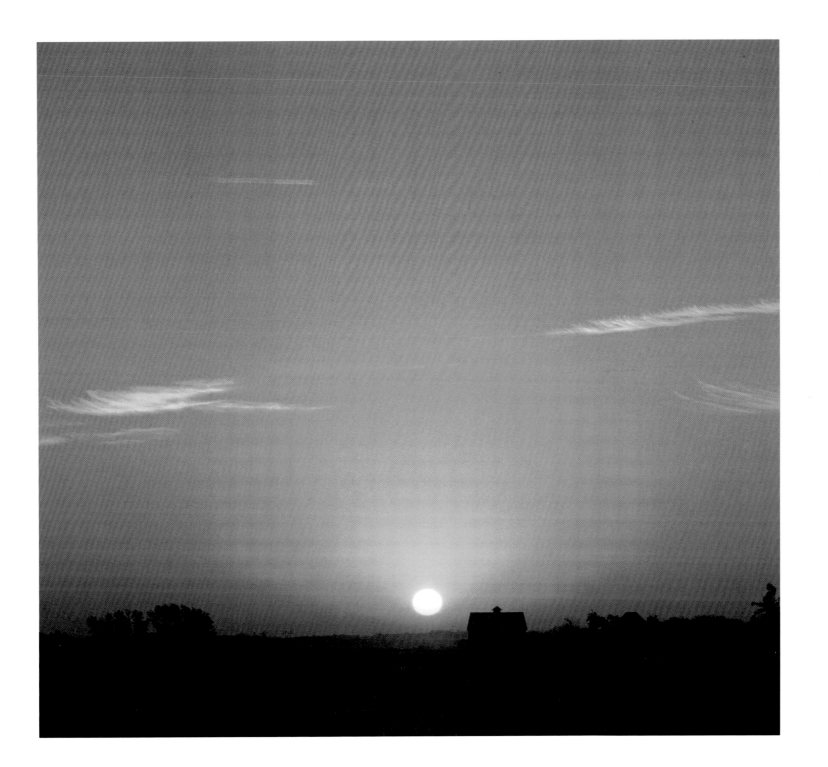

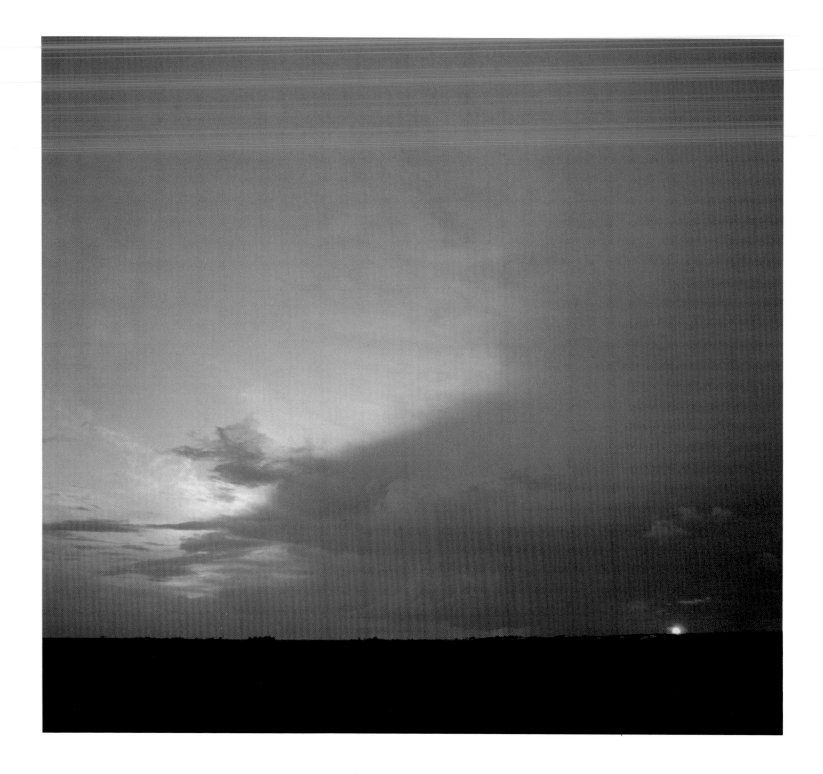

18

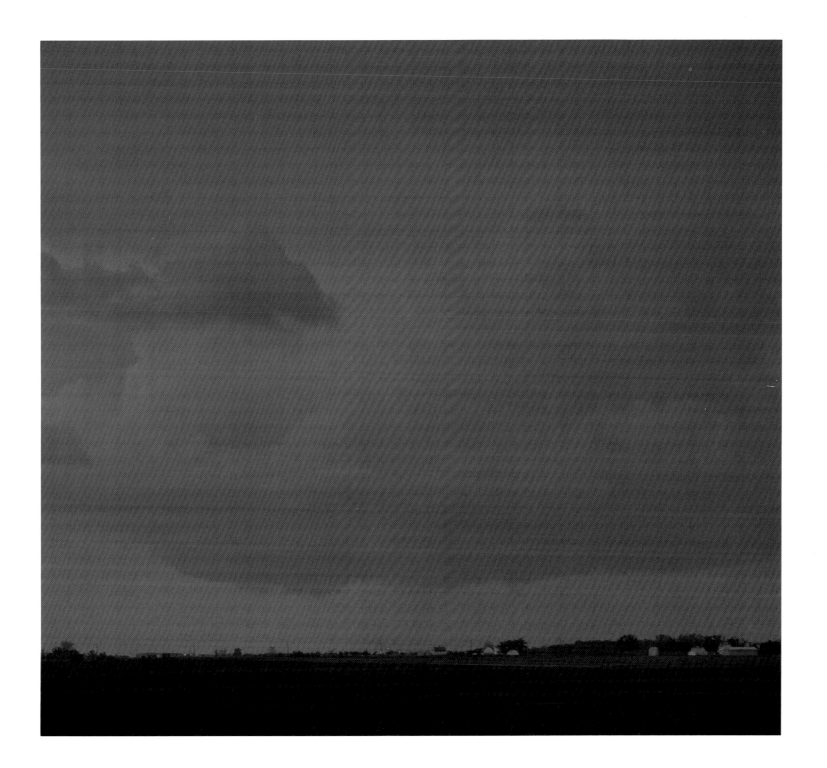

19

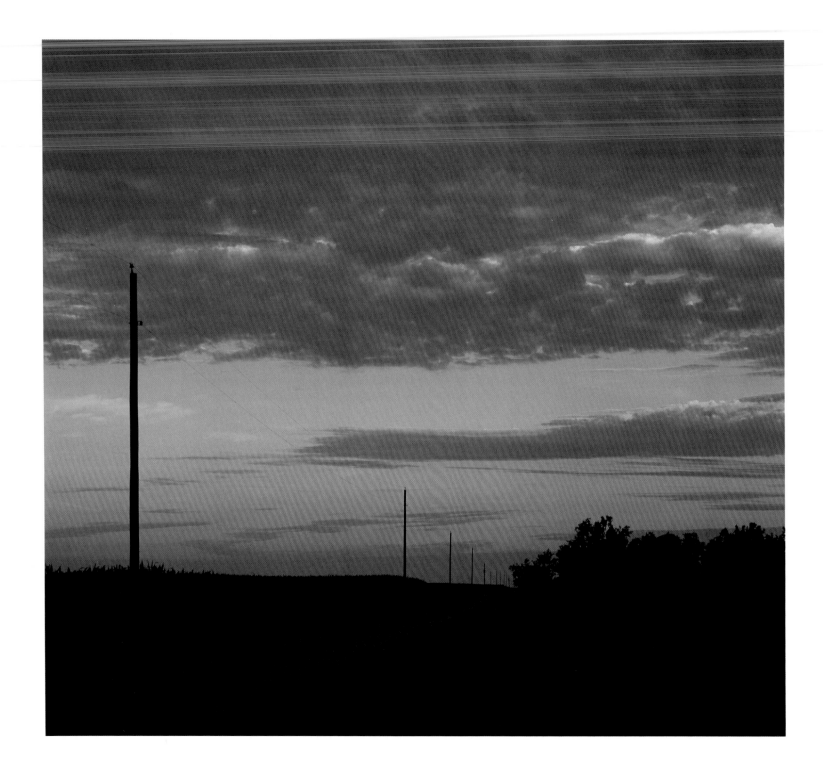

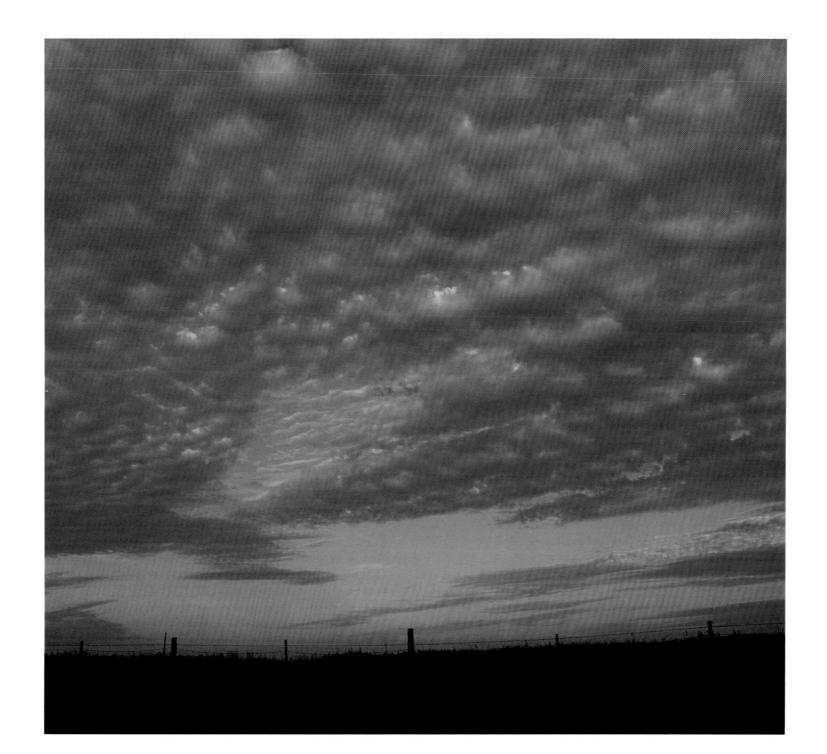

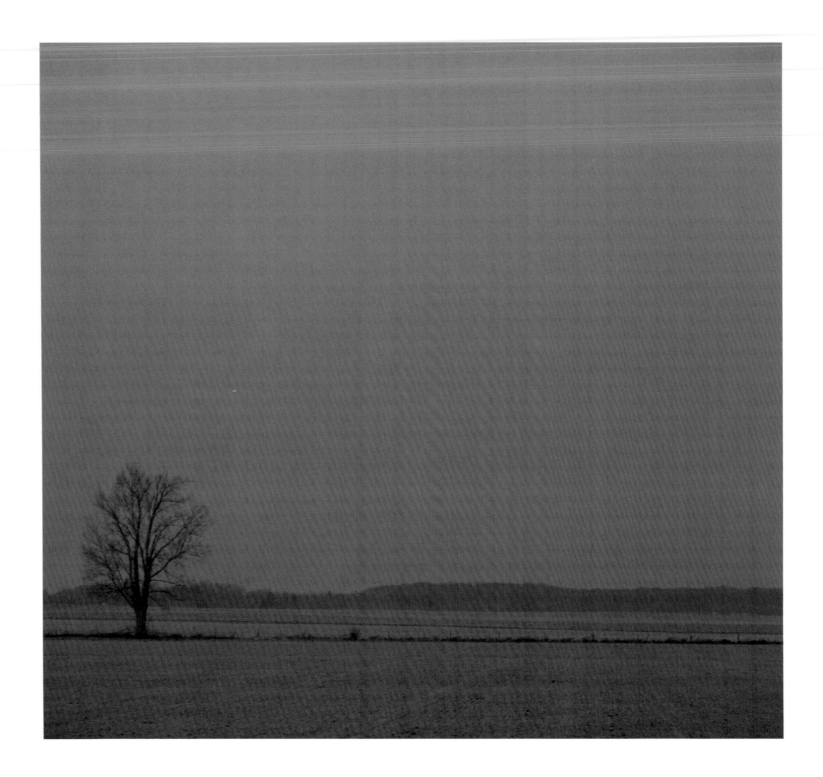

22

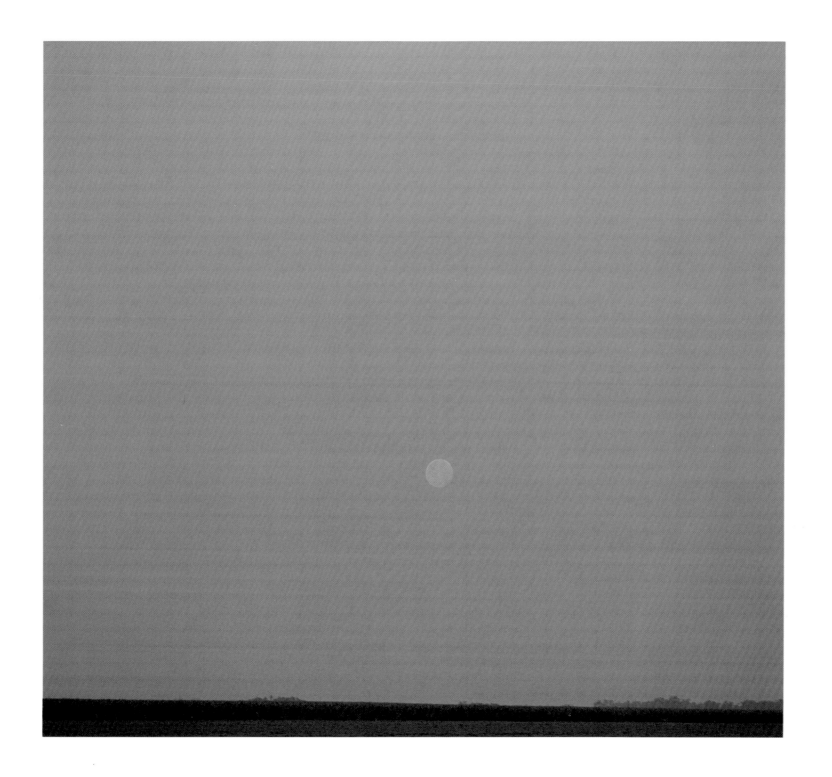

23

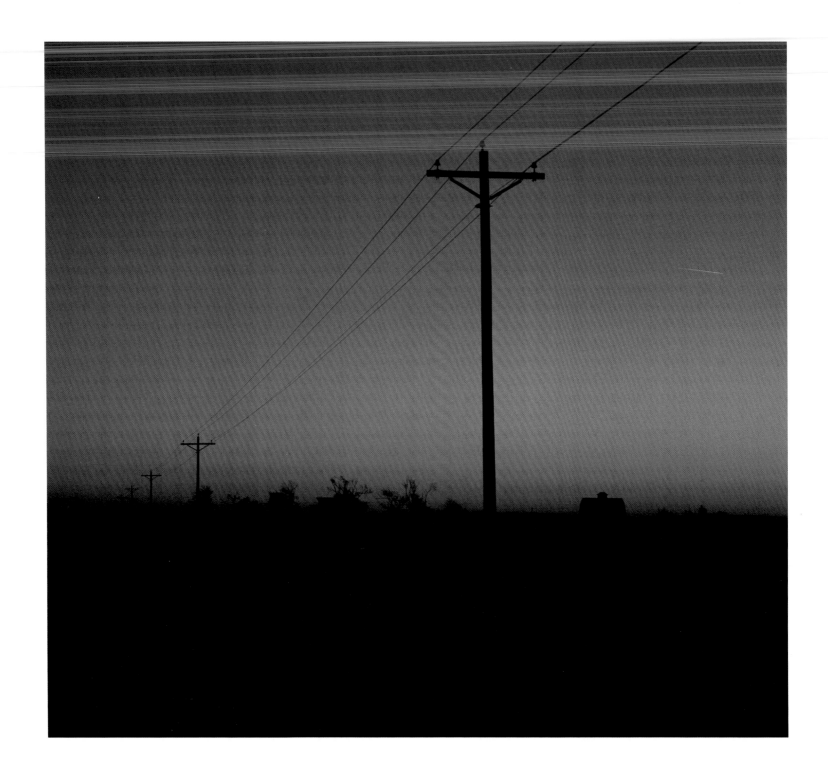

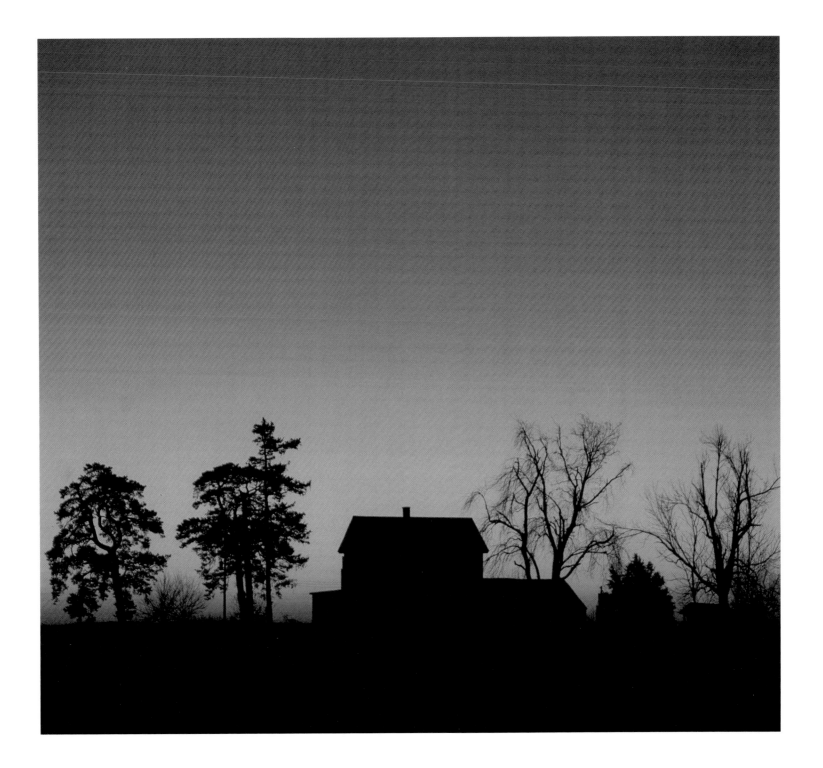

25

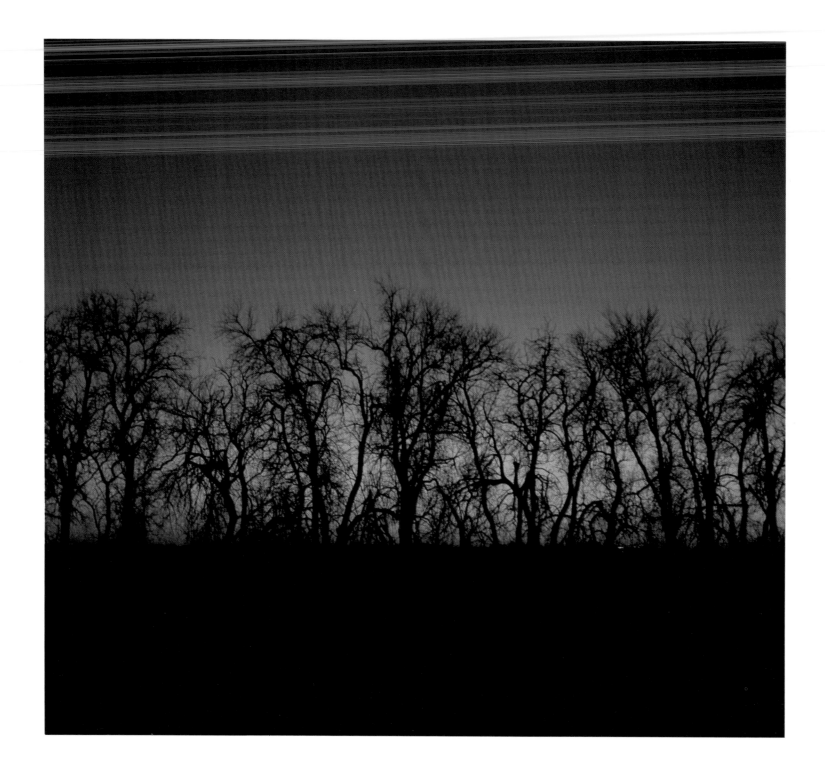

26

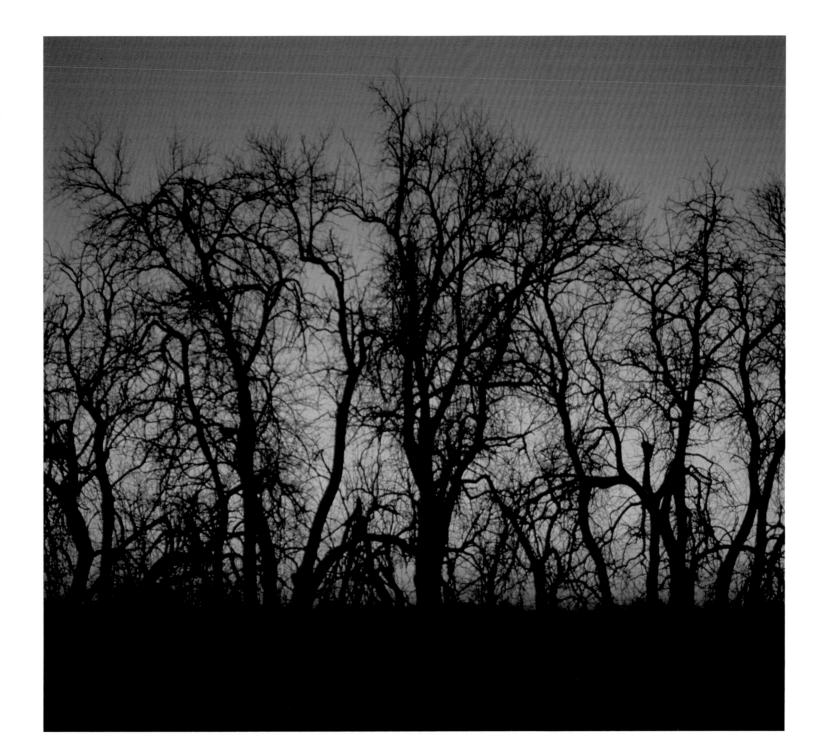

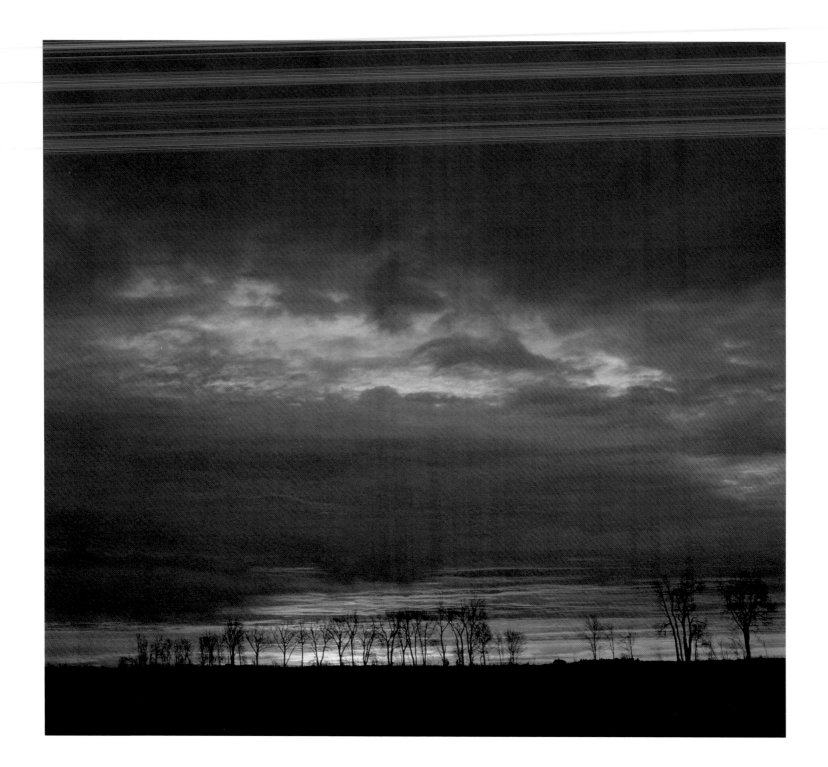

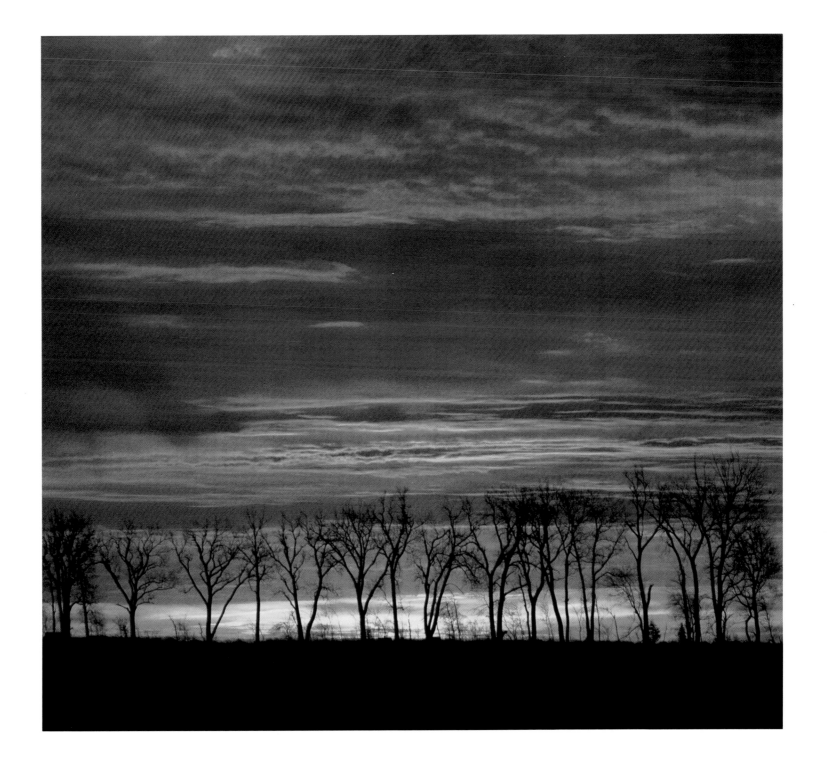

29

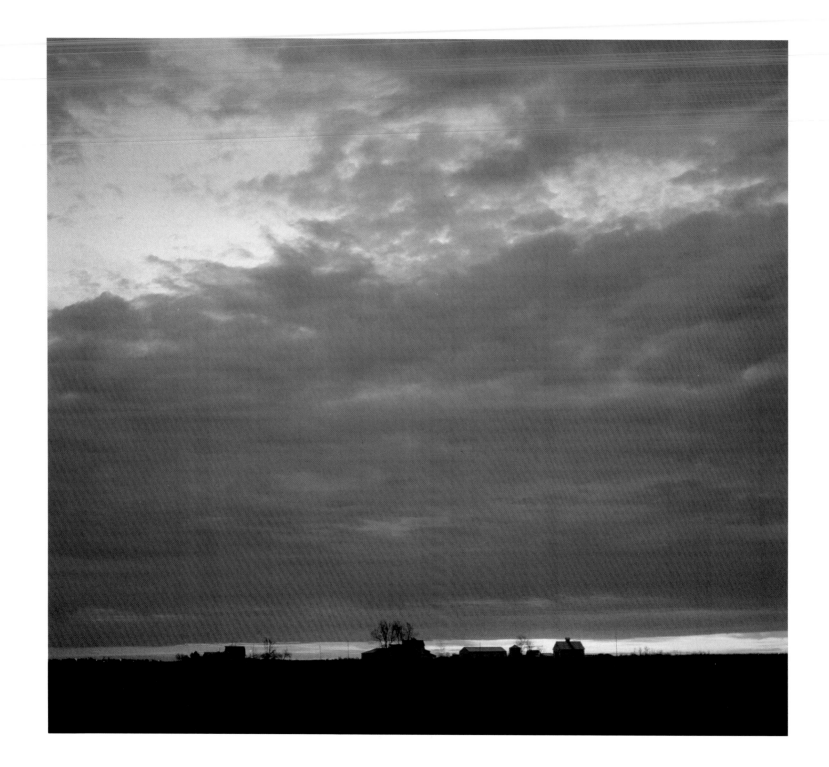

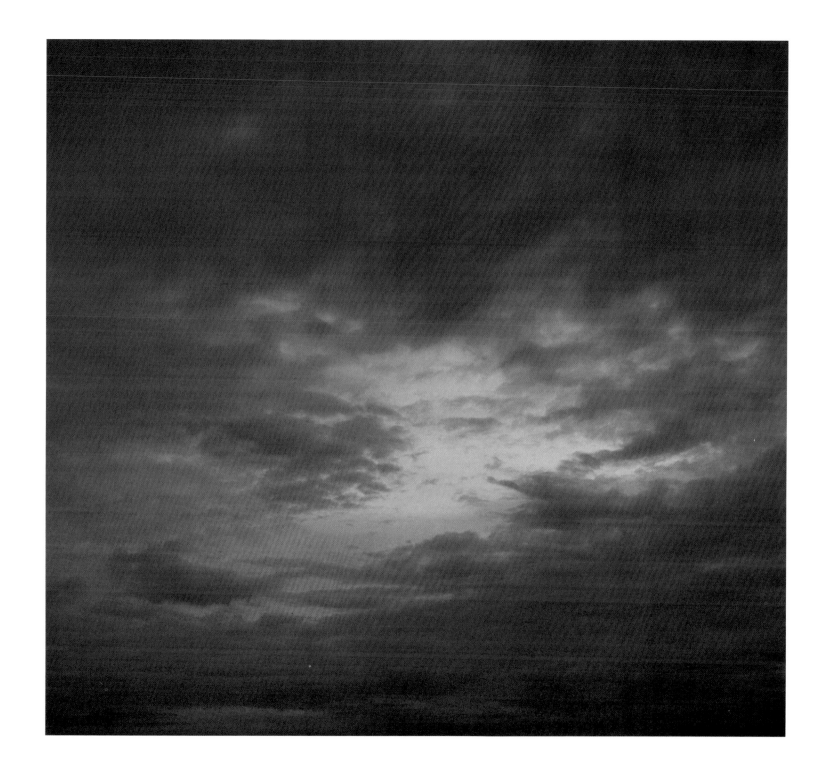

31

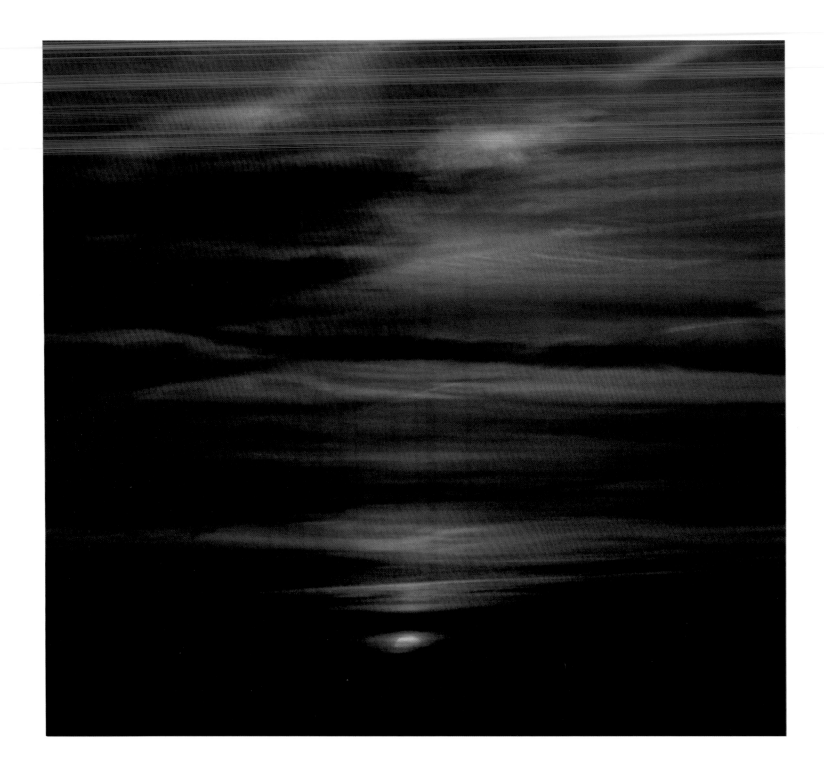

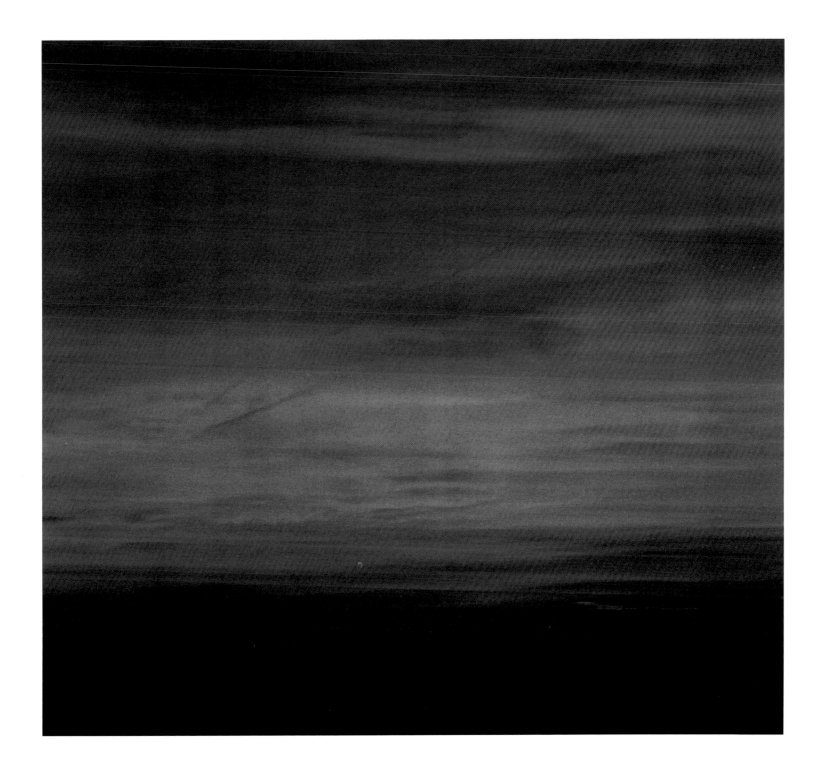

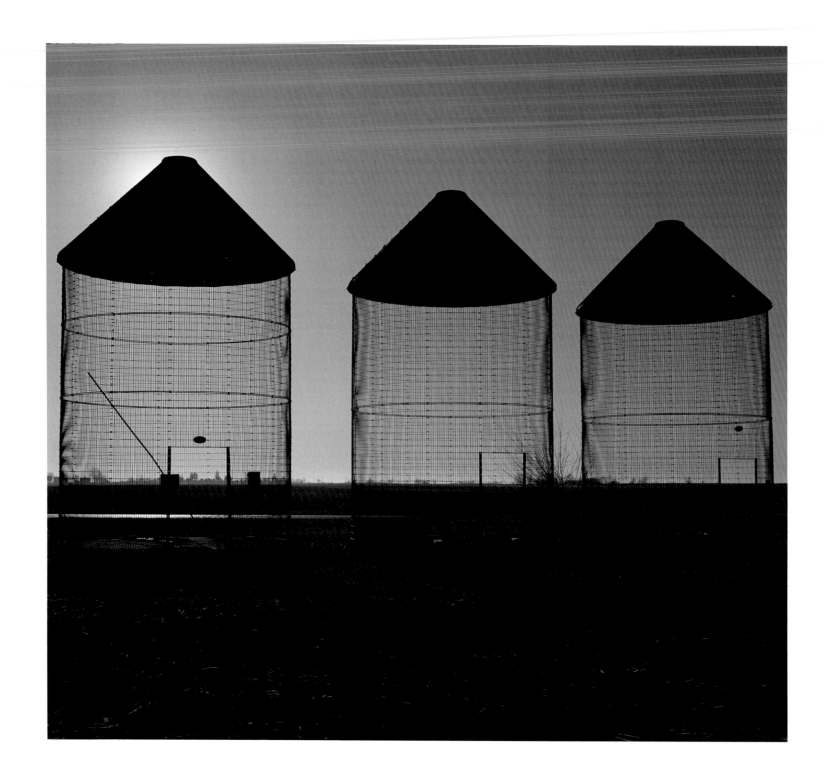

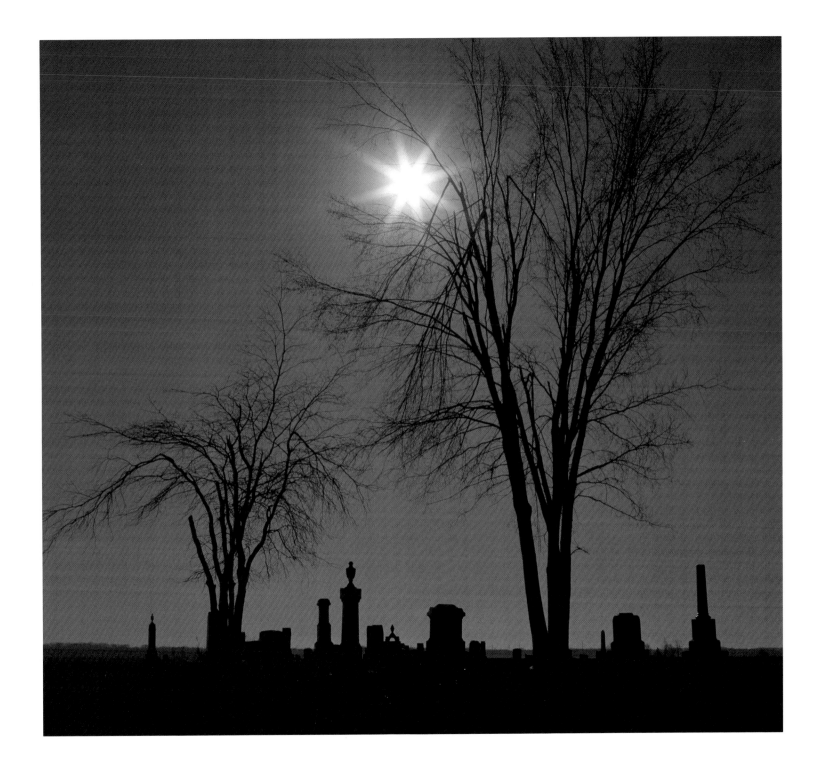

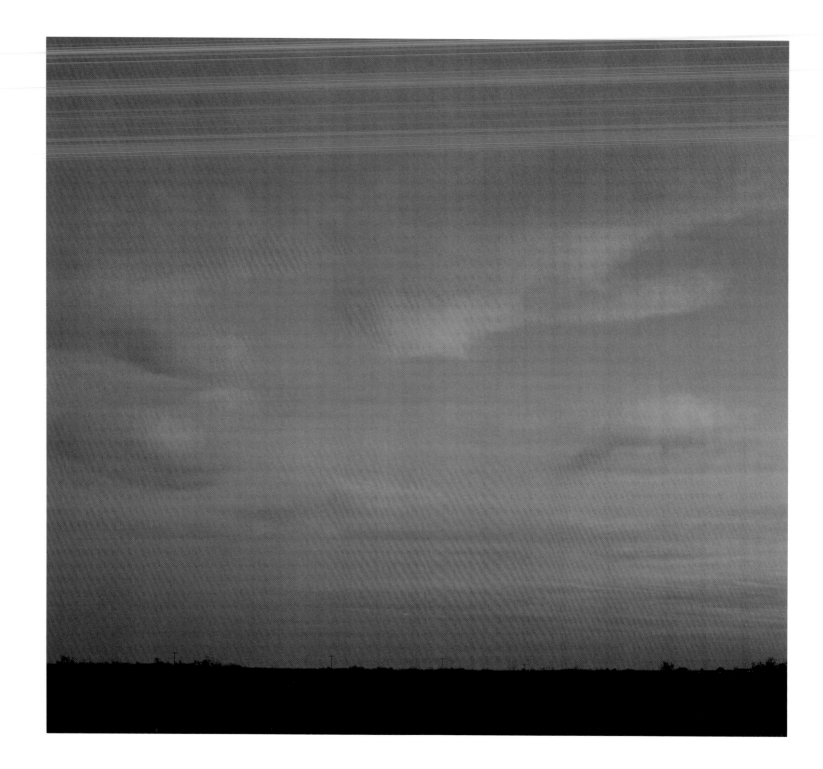

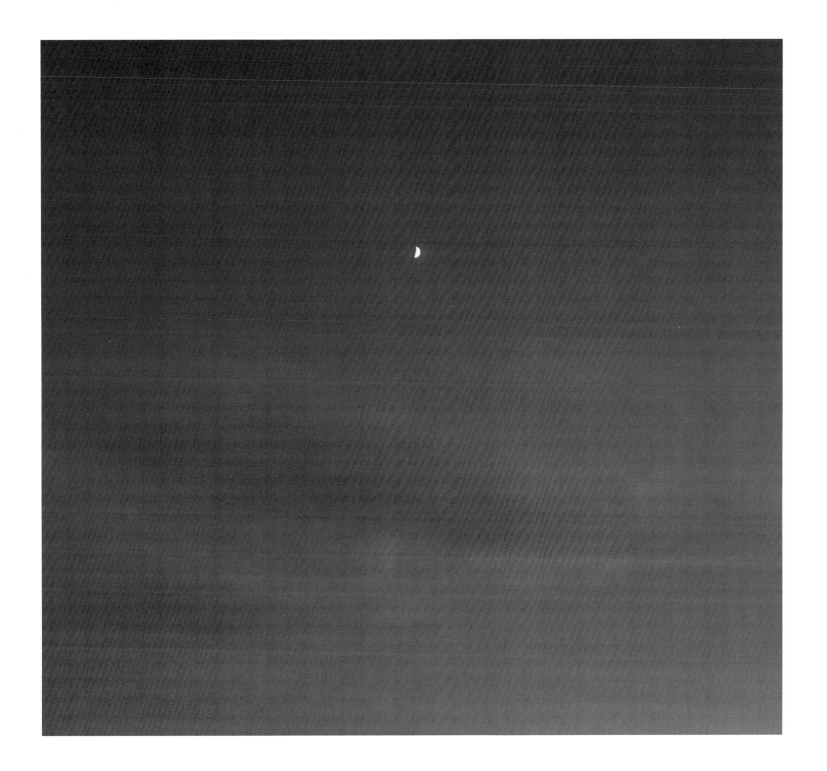

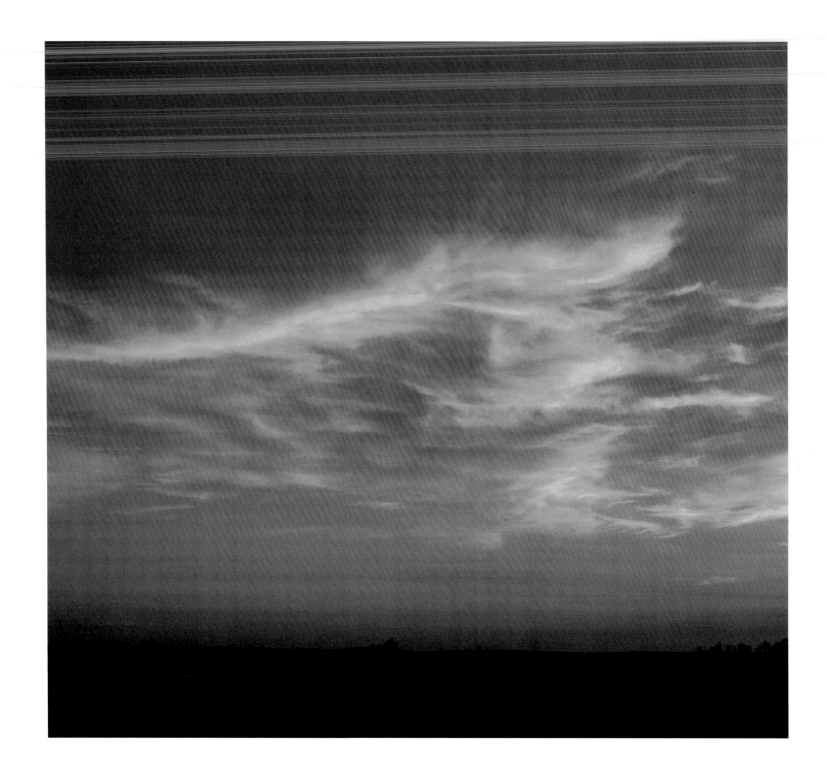

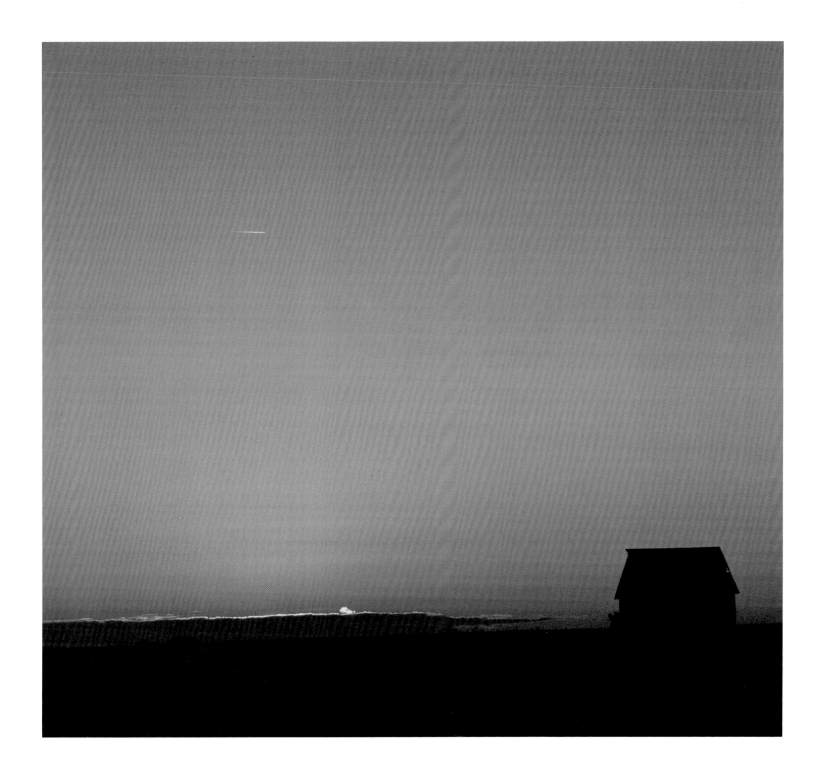

39

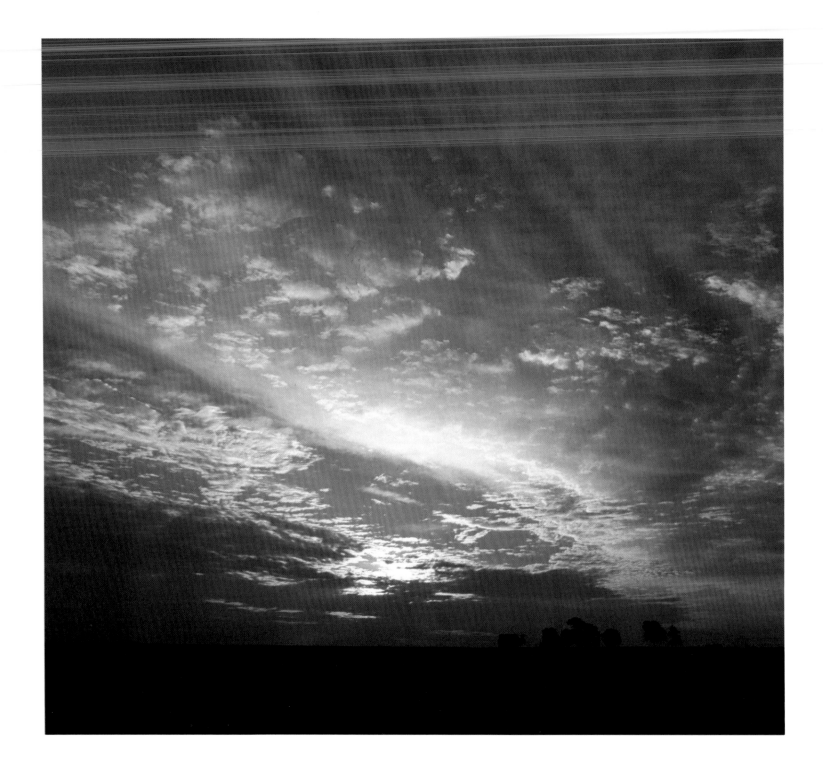

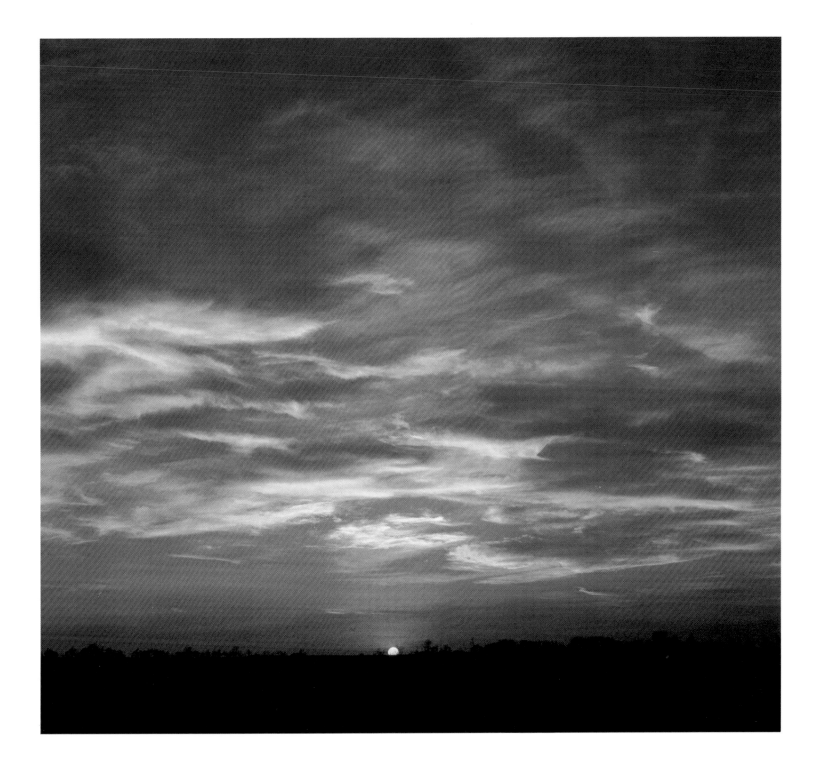

41

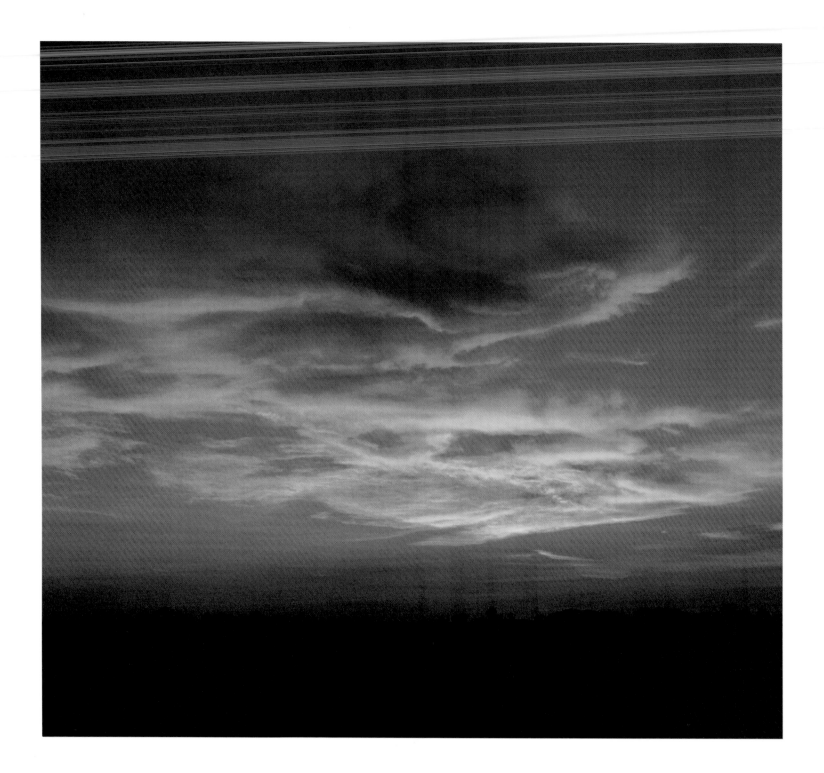

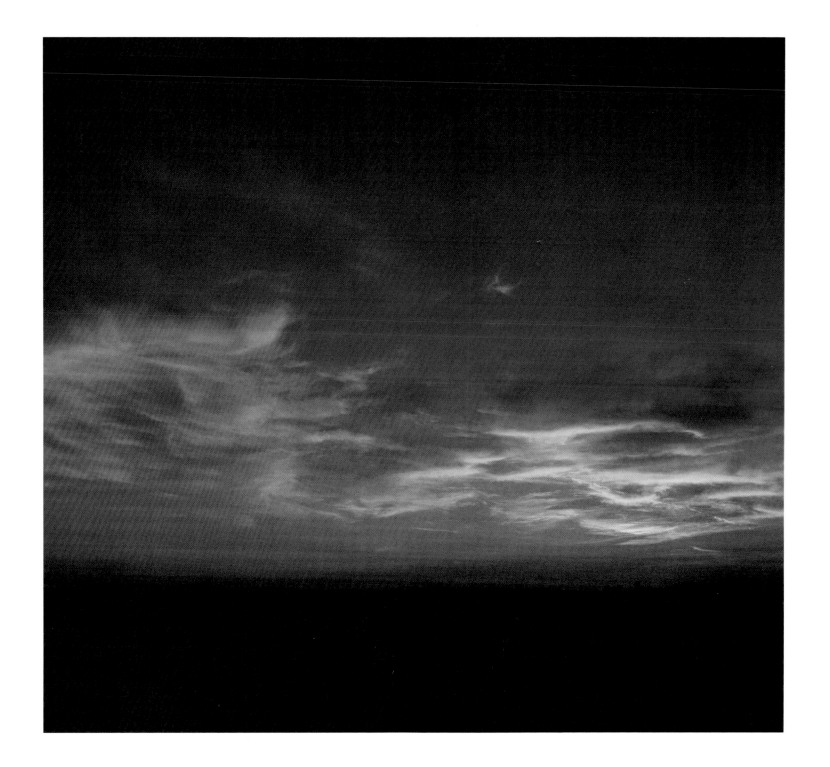

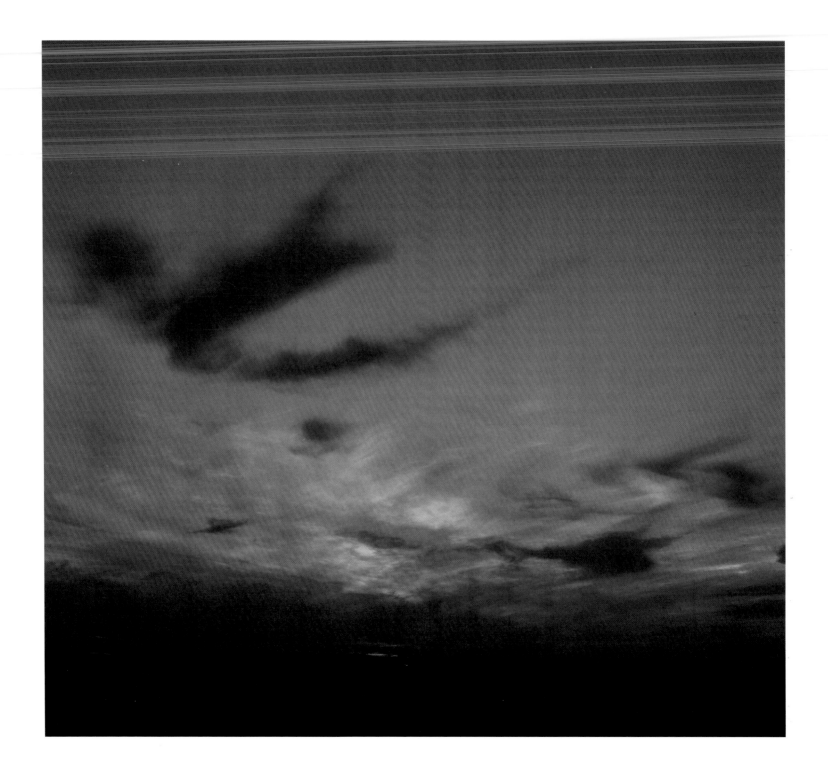

44

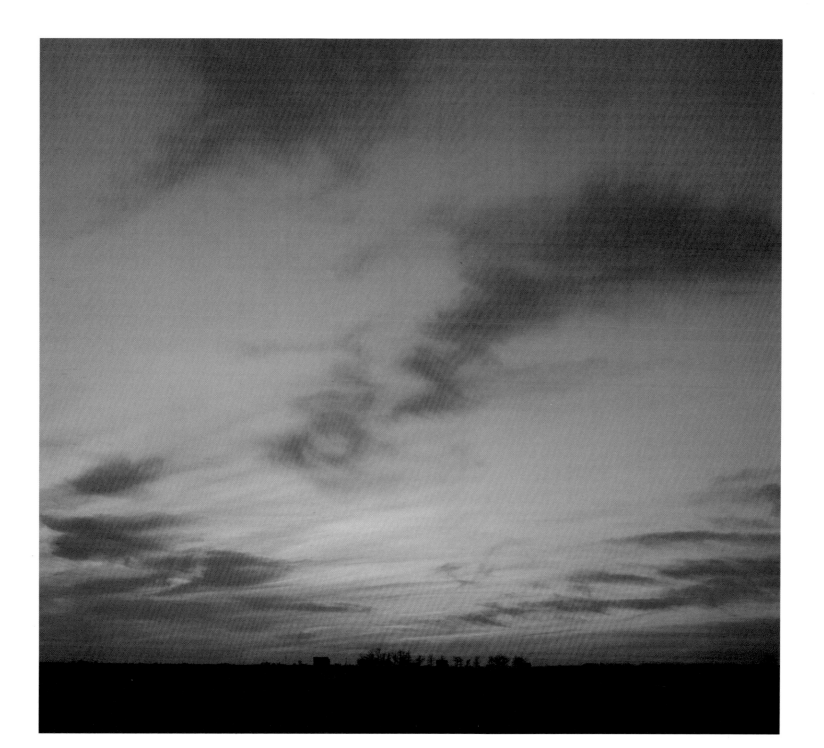

45

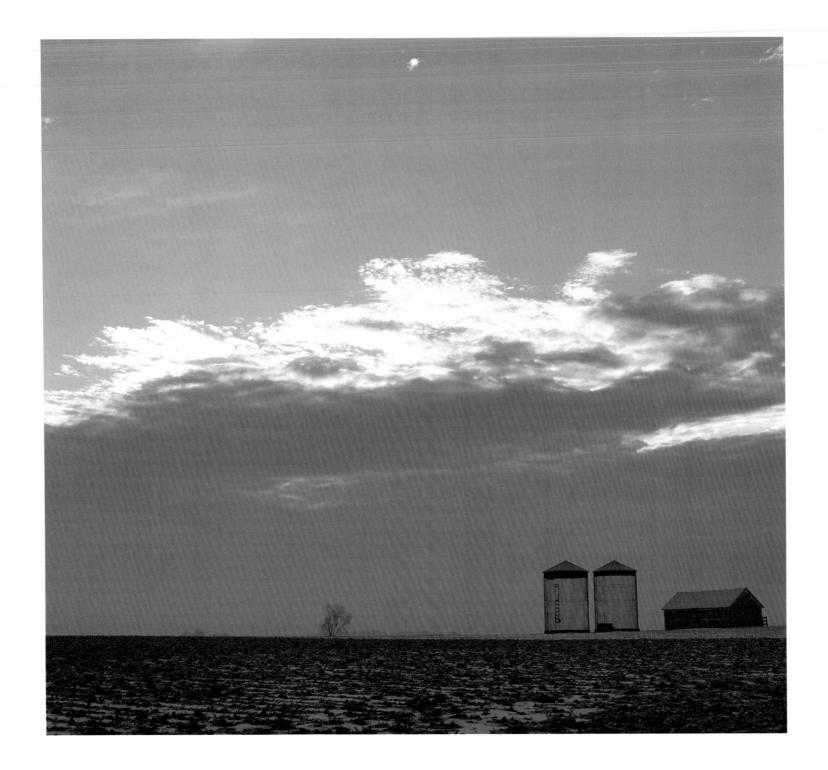

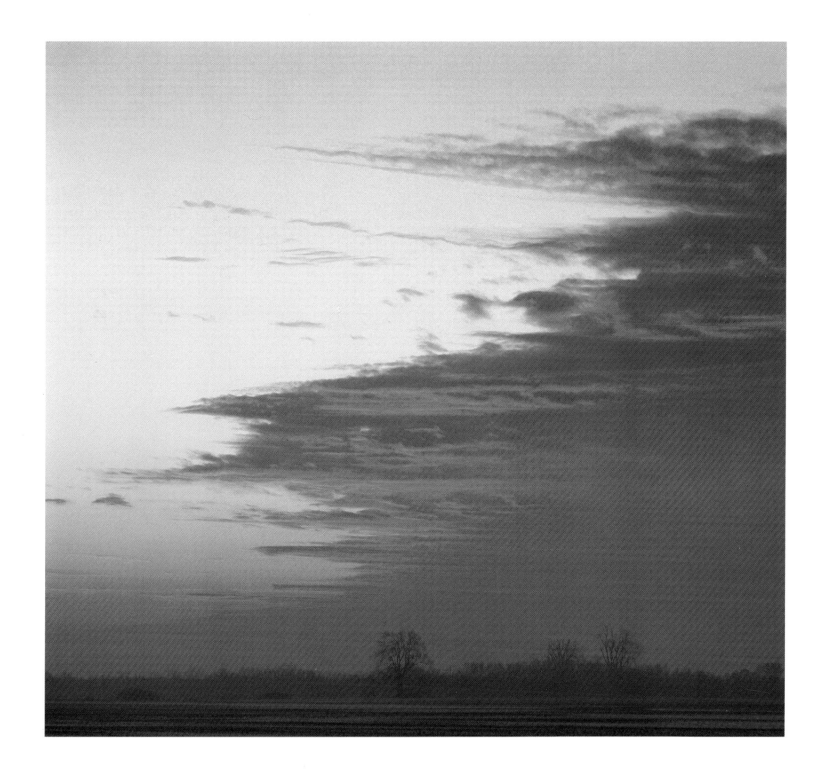

47

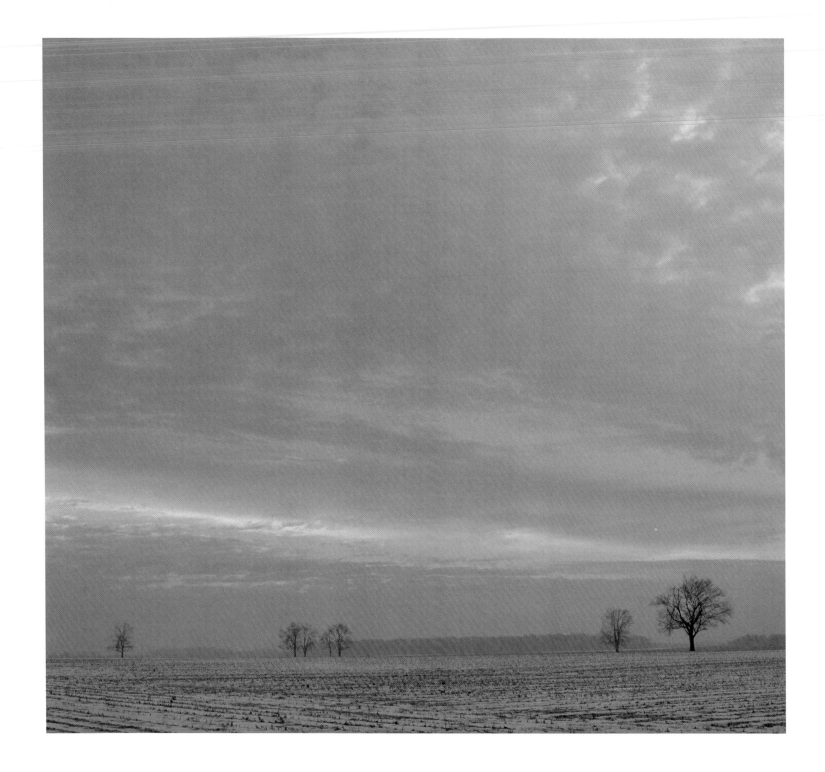

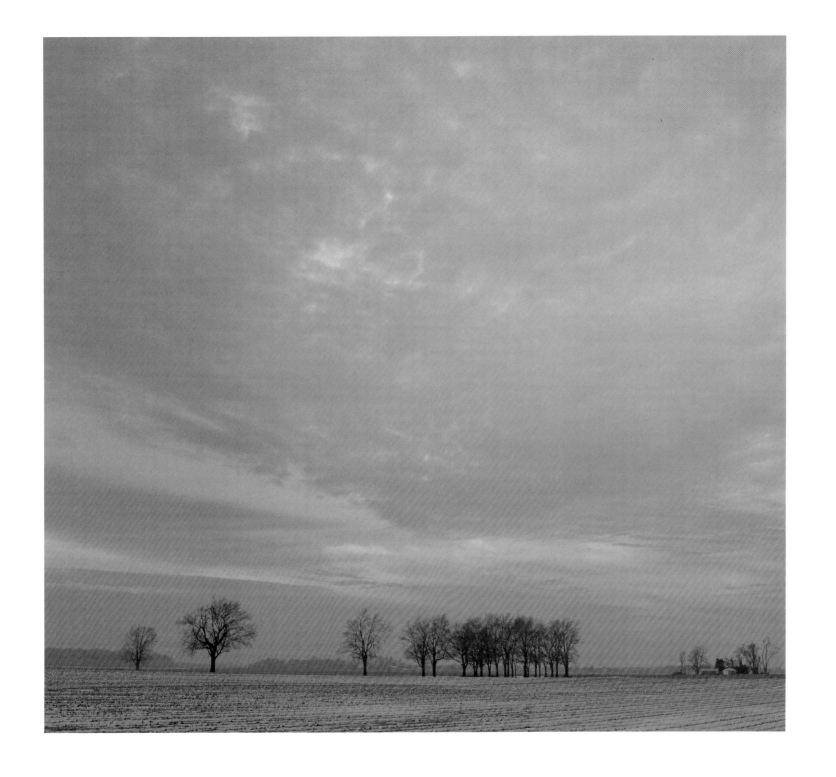

49

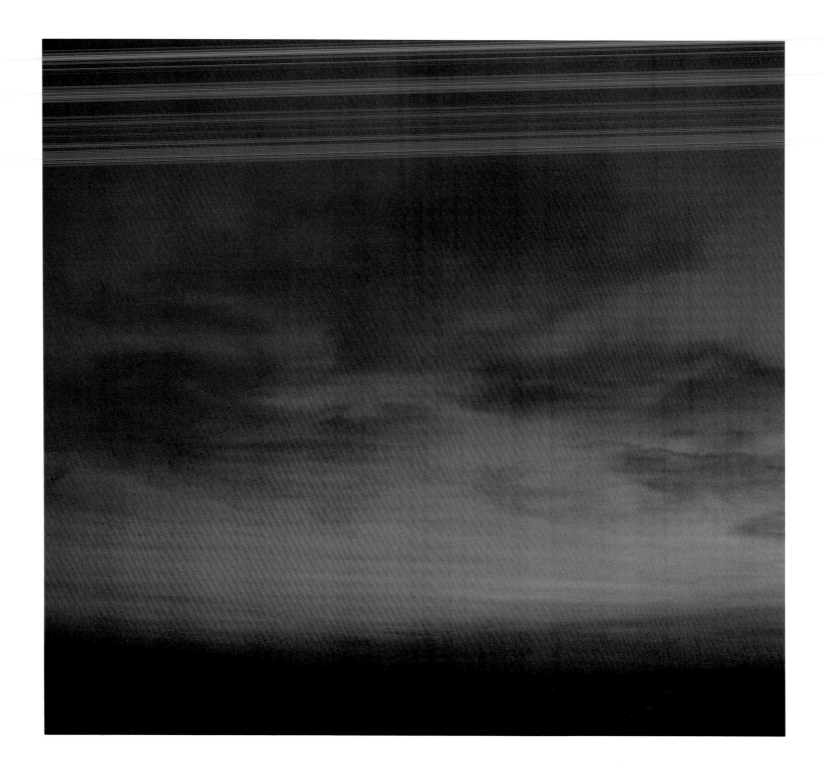

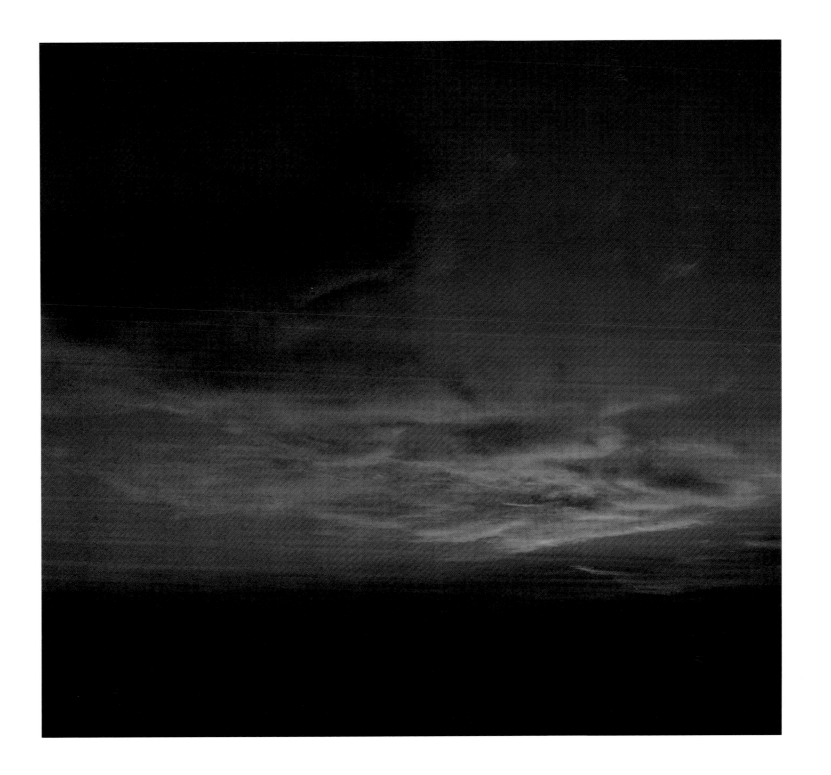

51

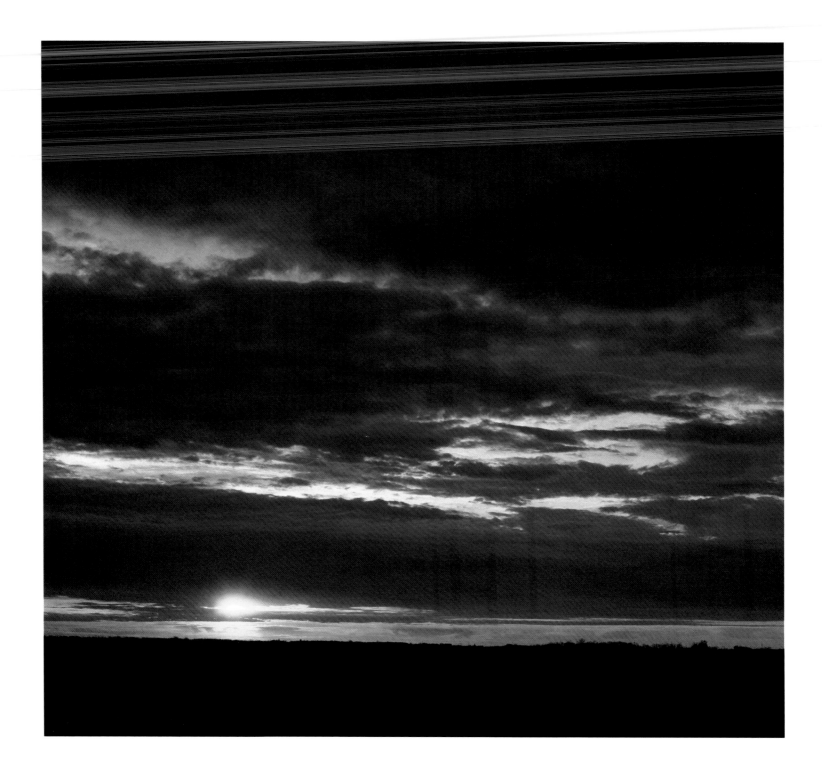

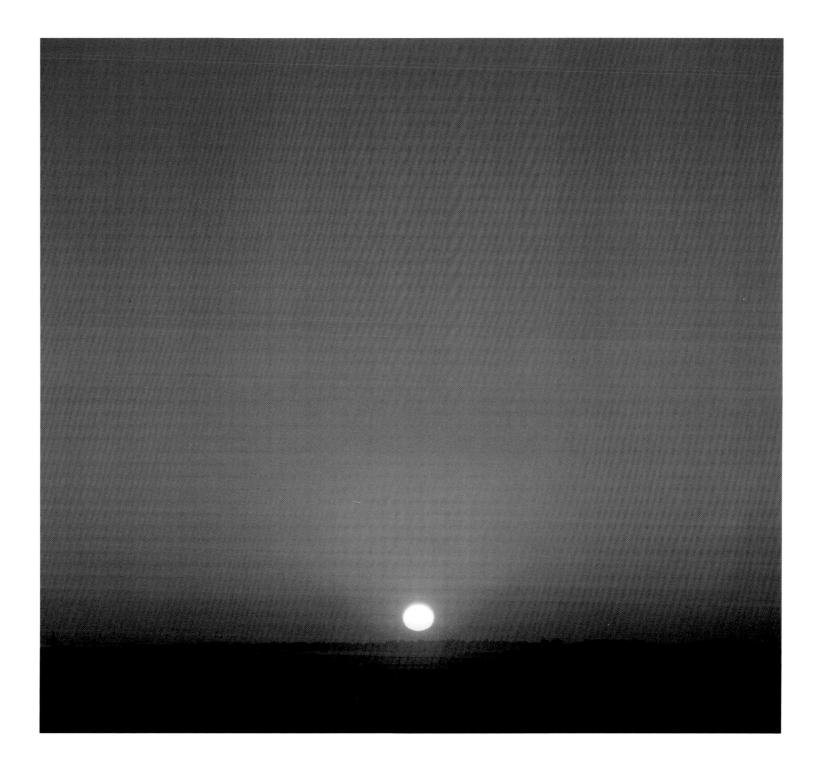

53

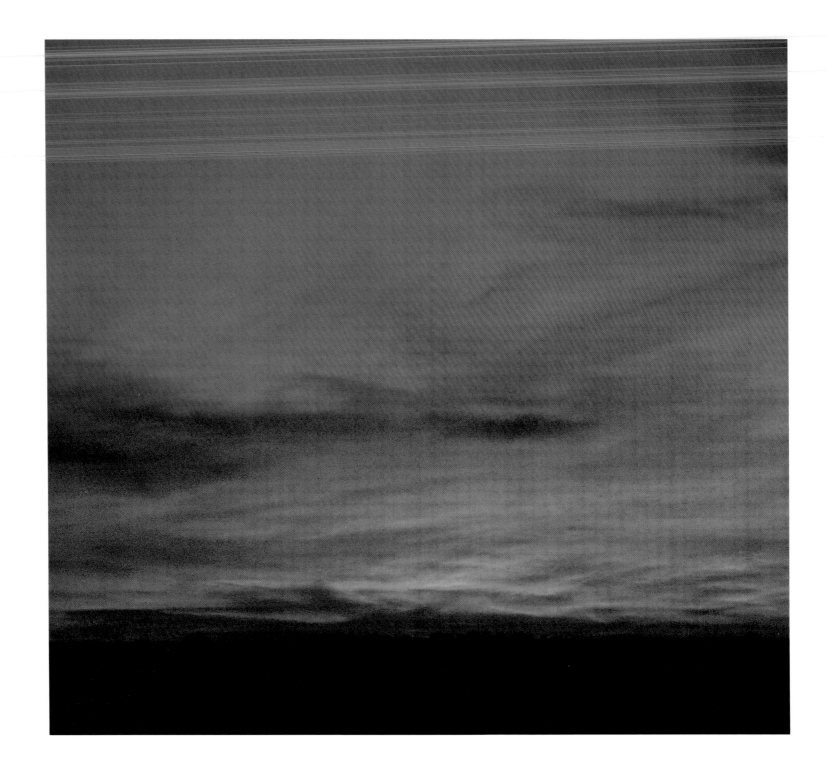

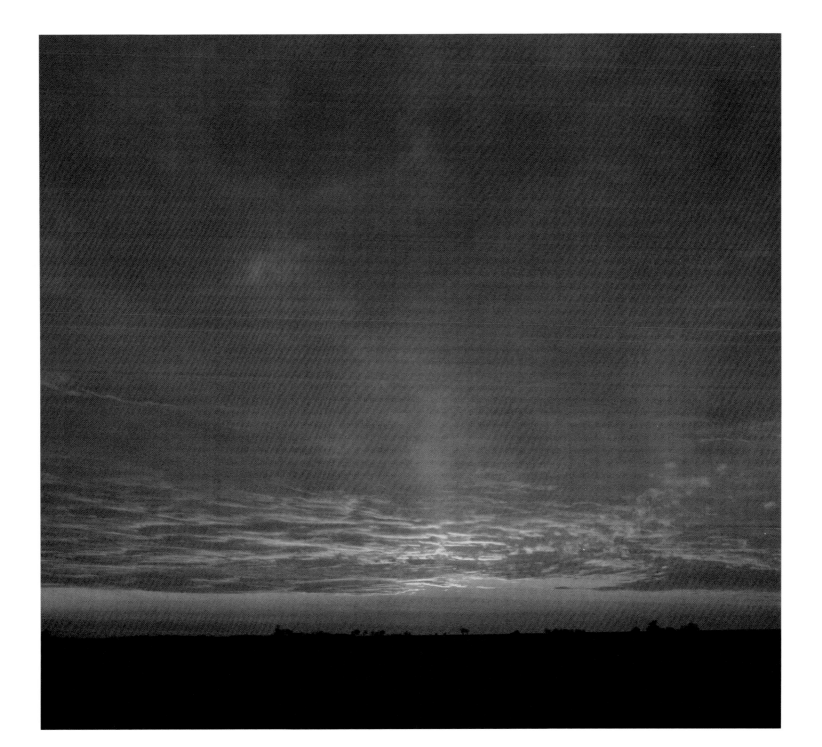

55

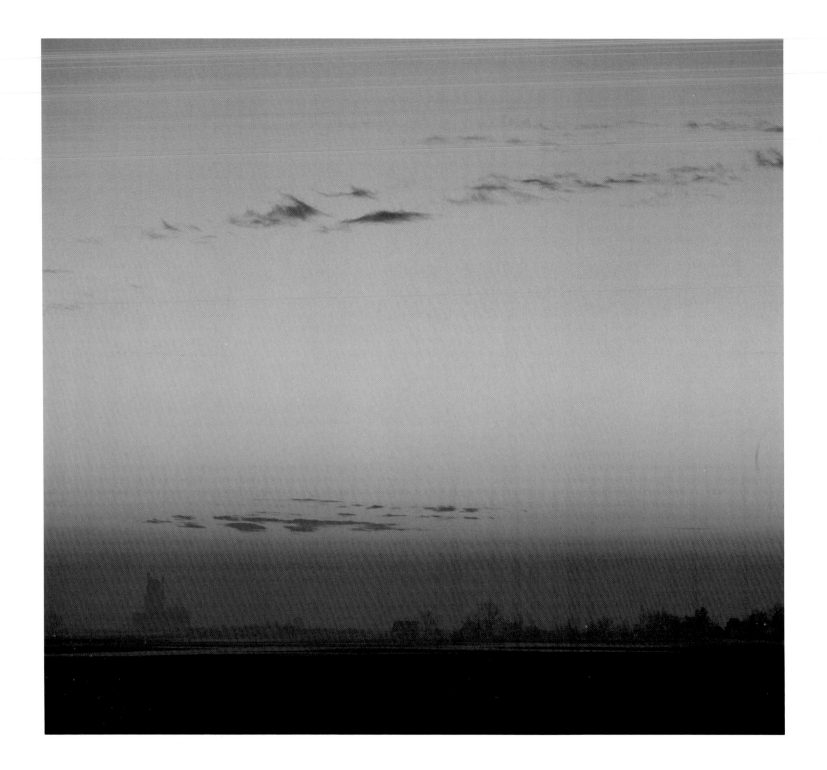

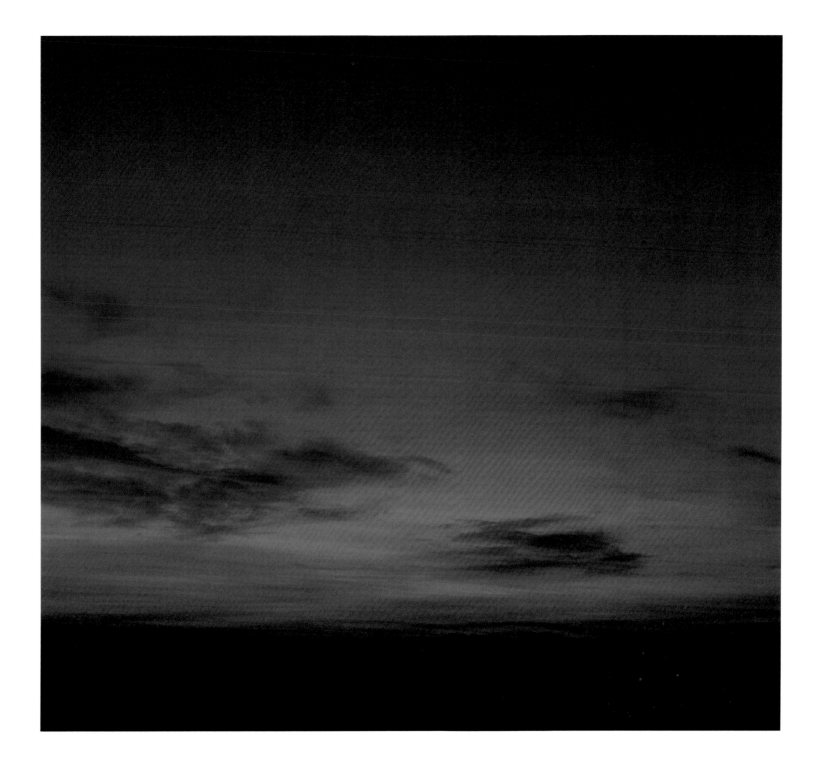

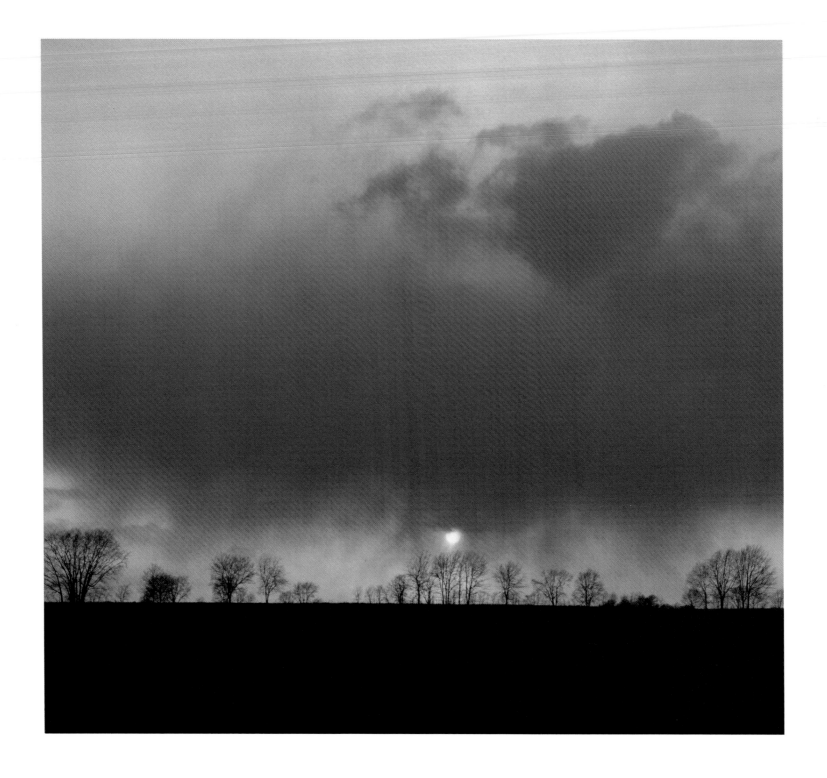

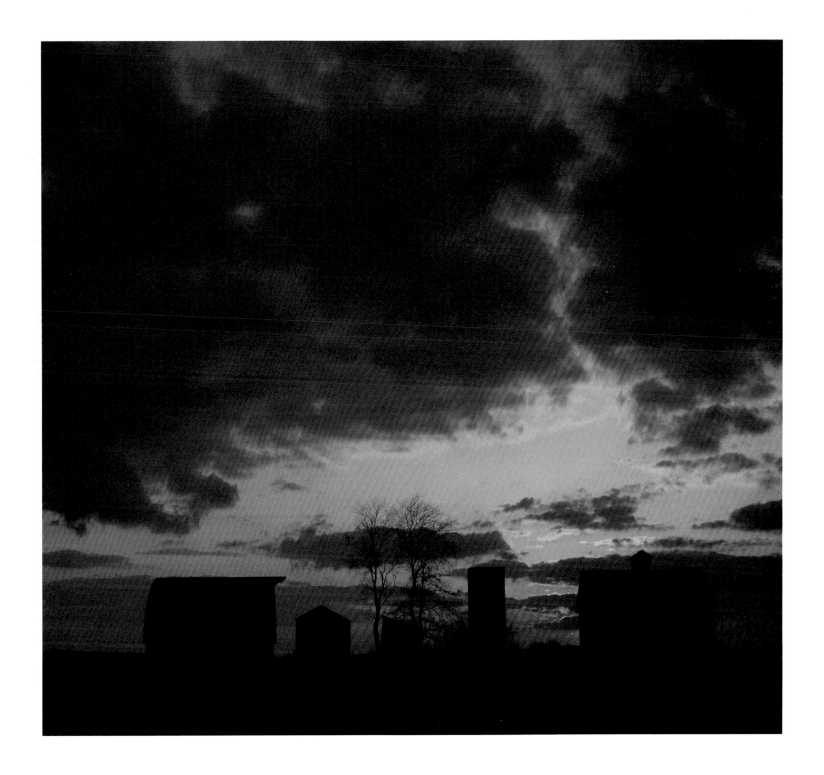

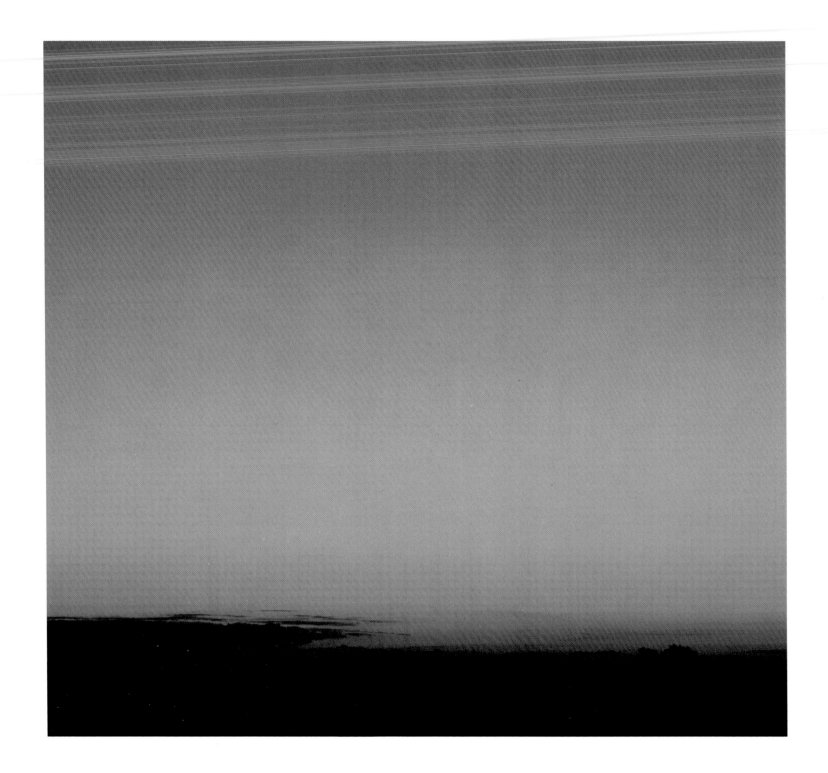

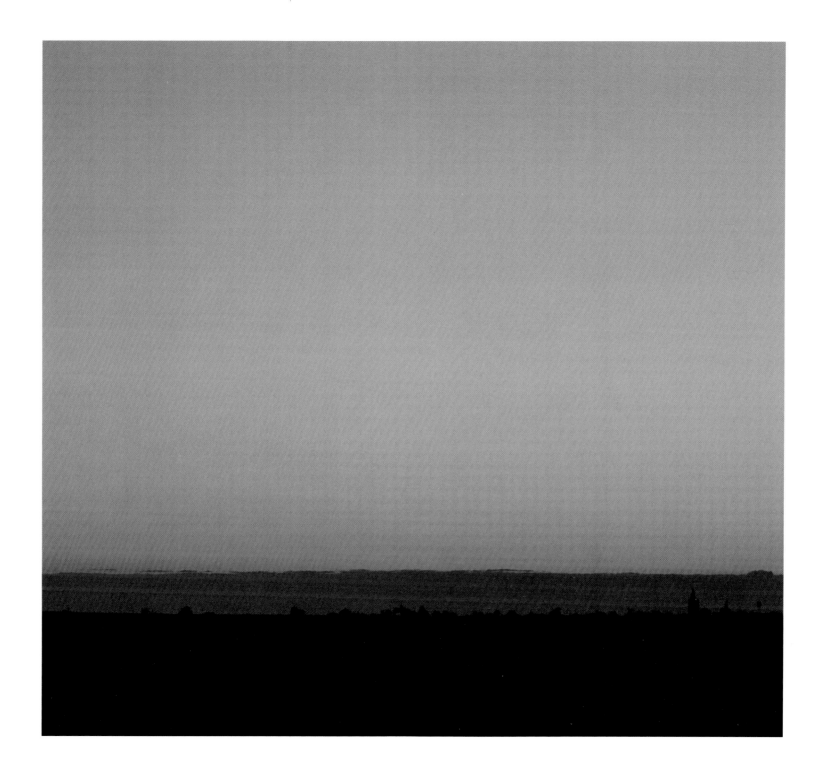

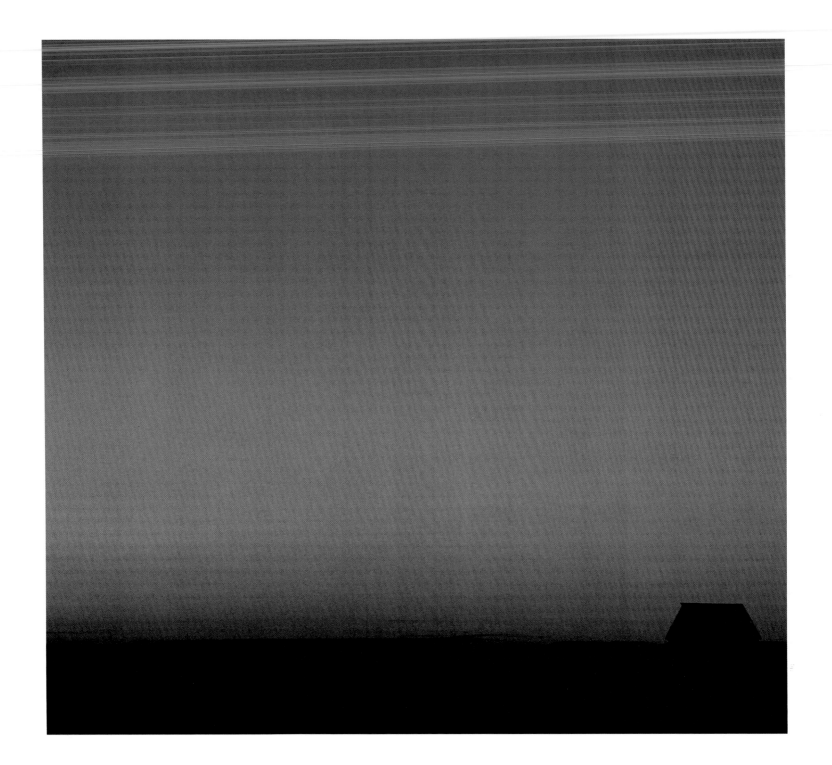

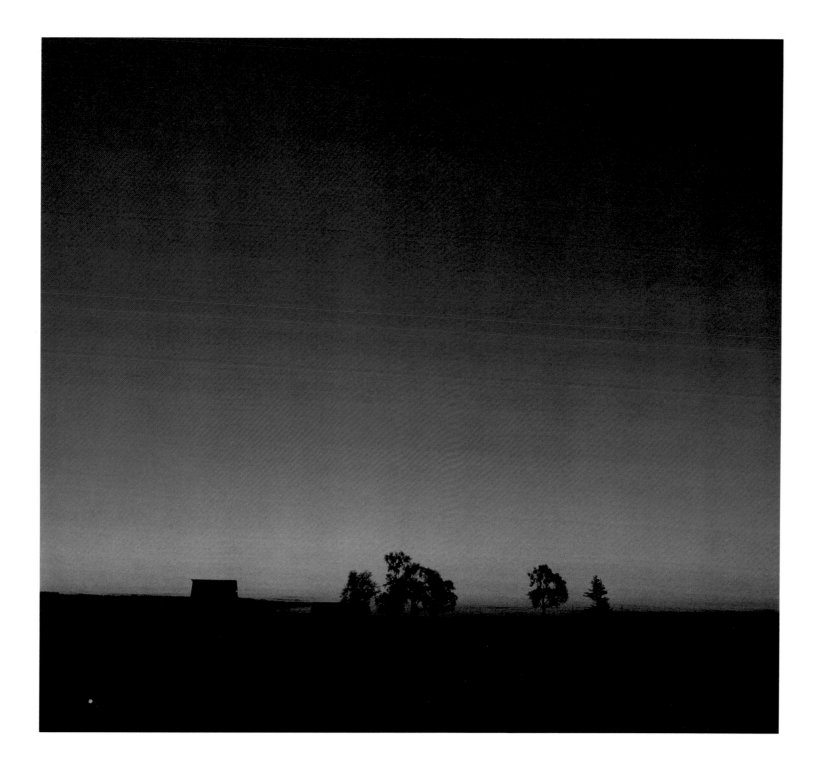

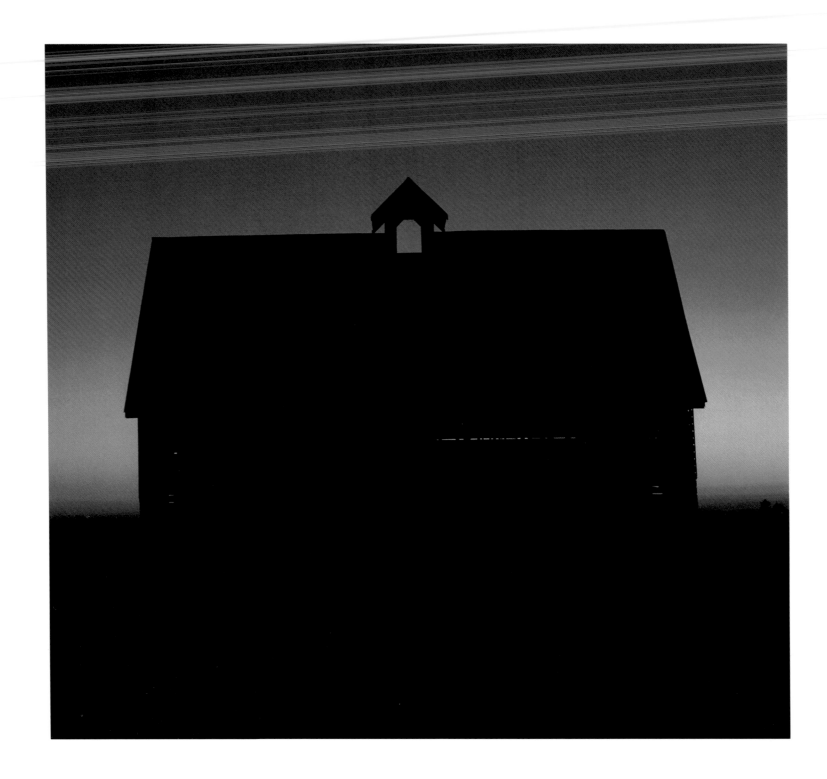

64

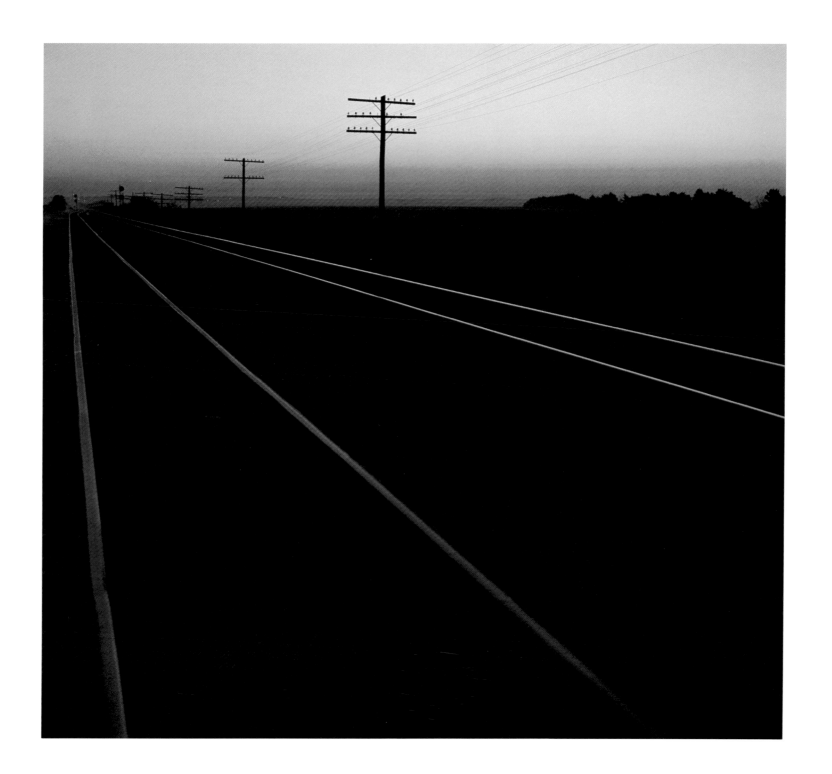

65

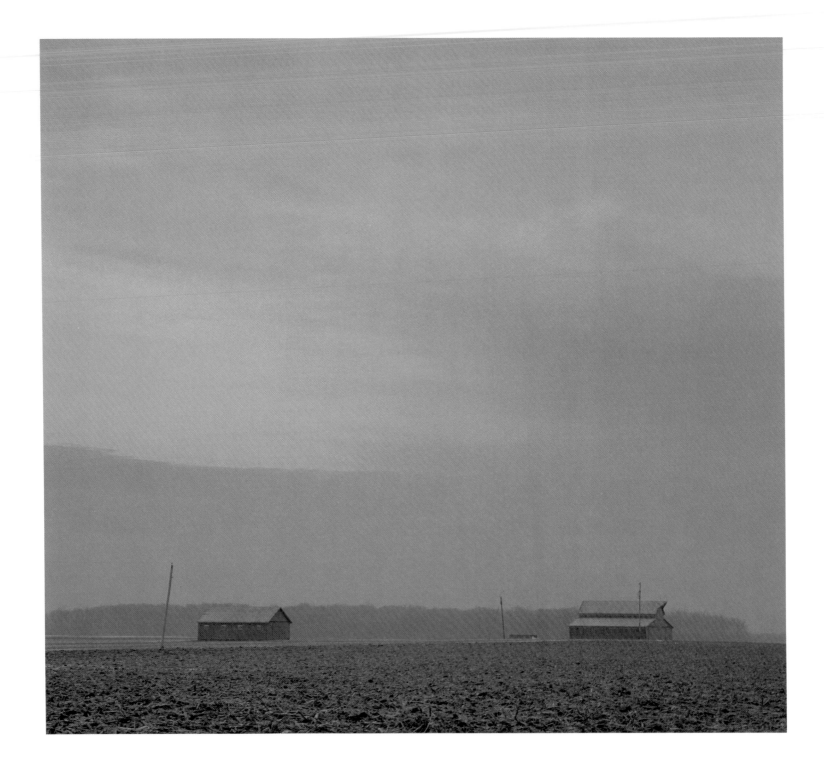

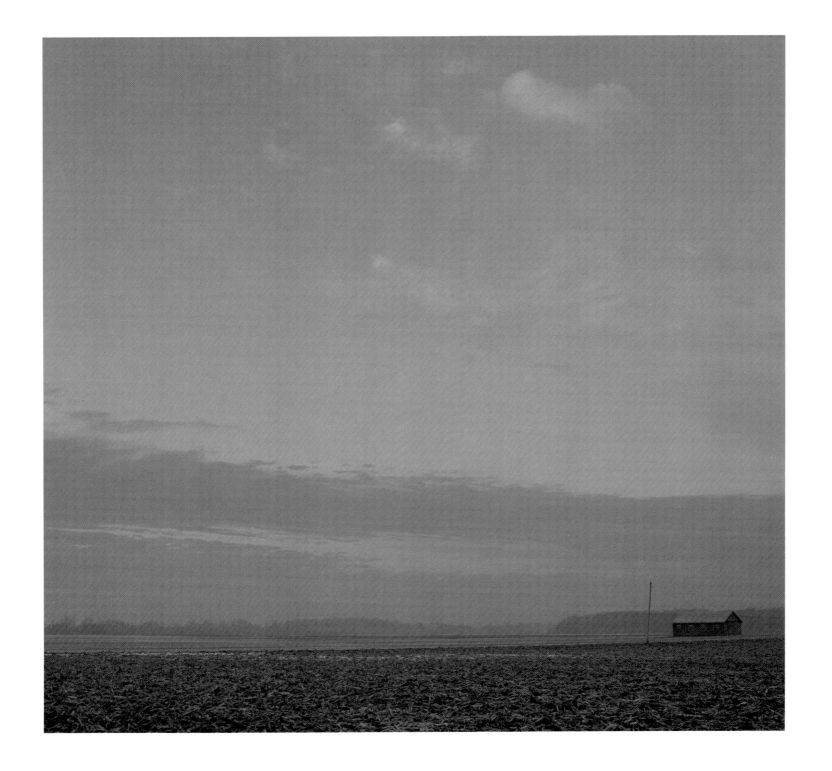

67

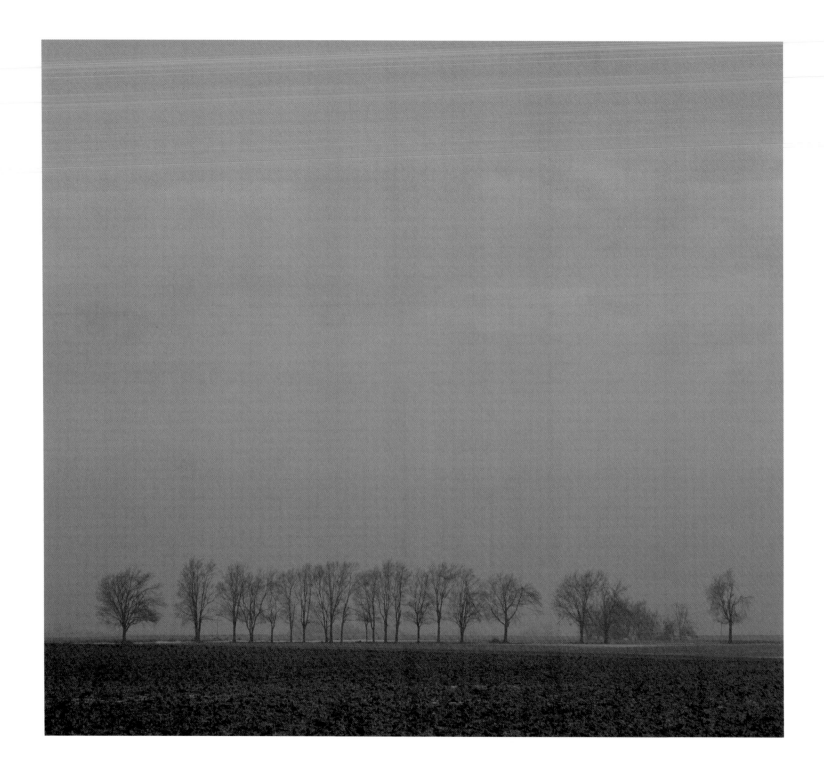

68

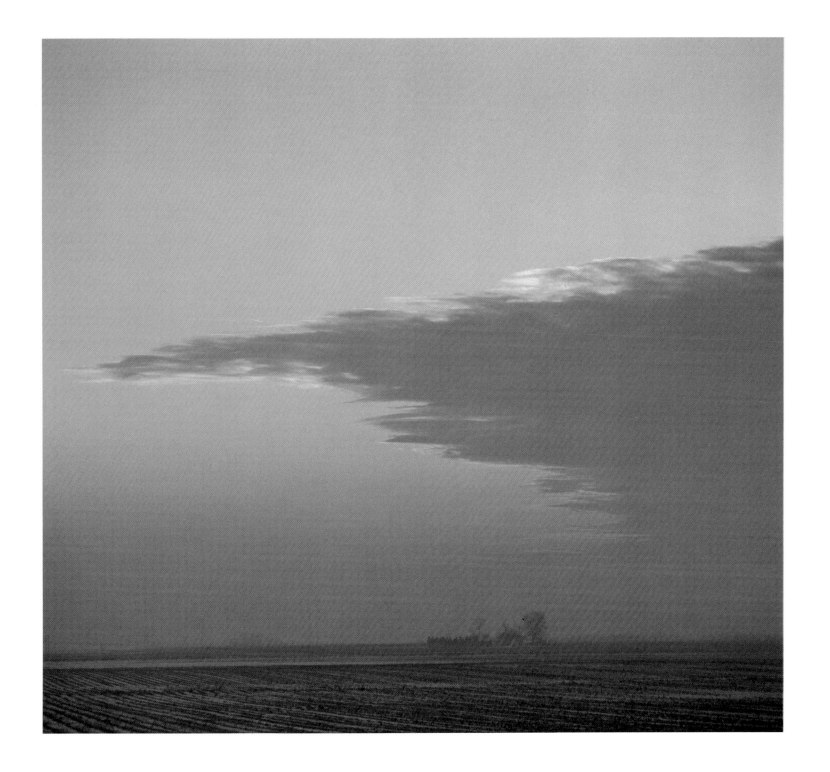

69

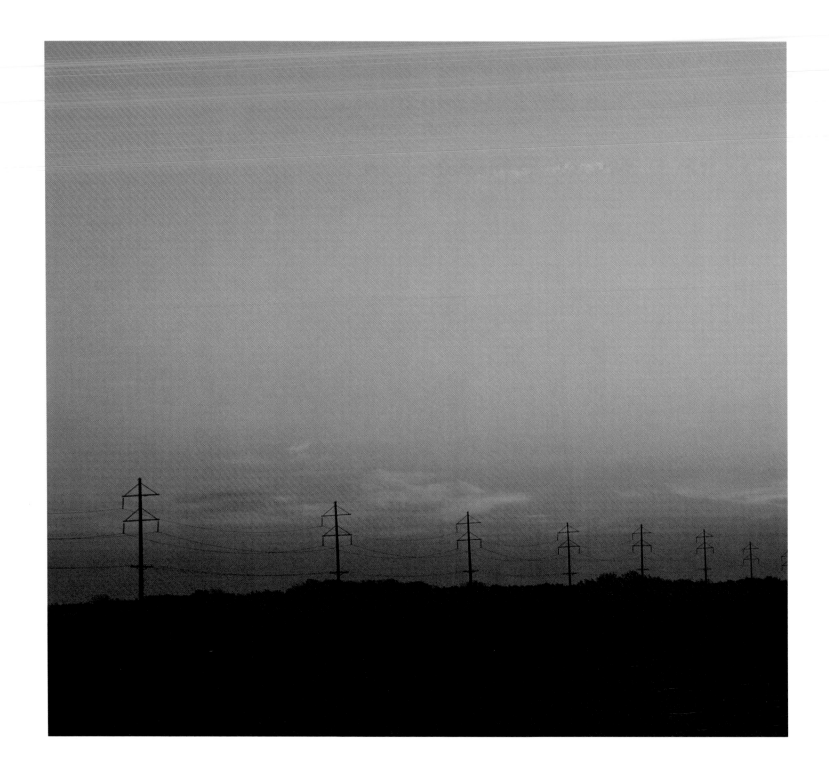

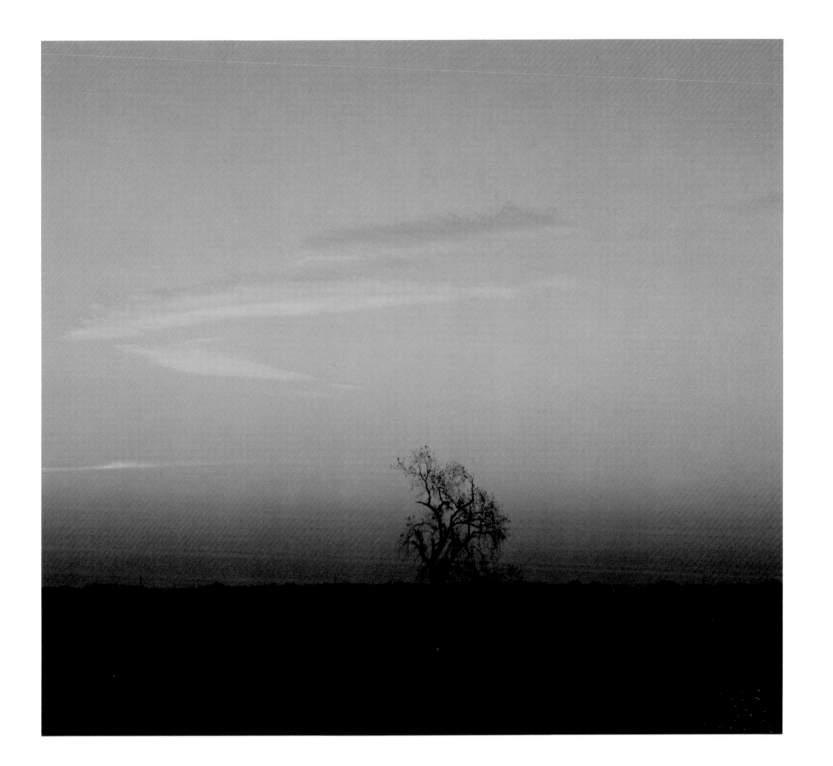

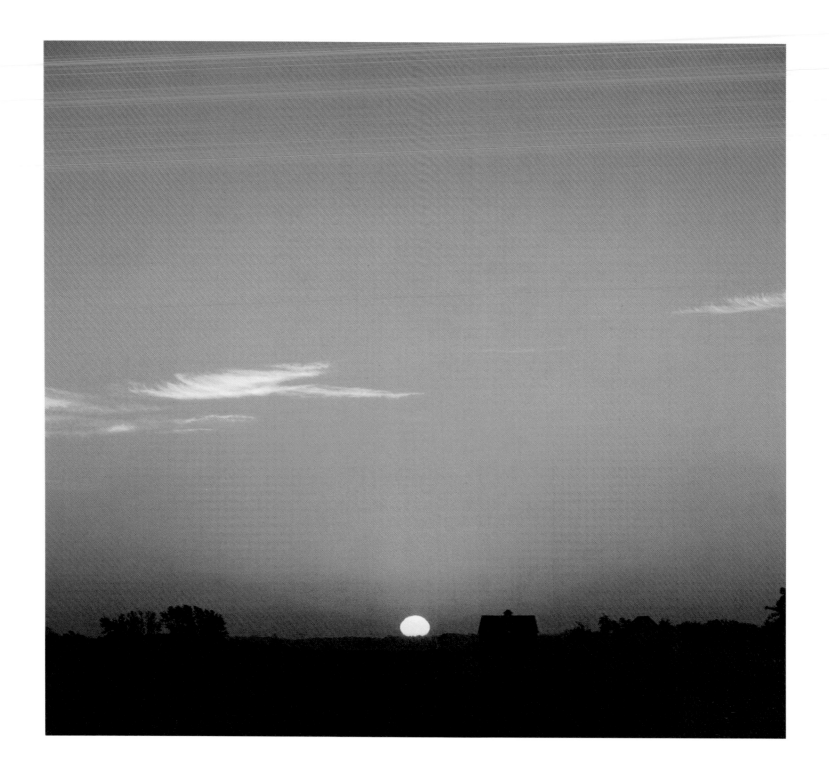

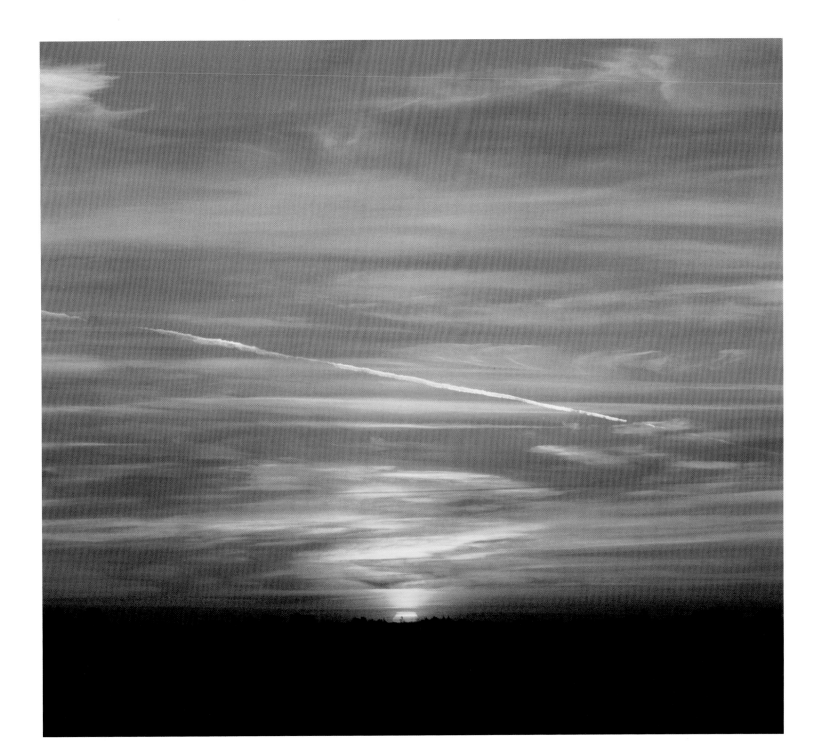

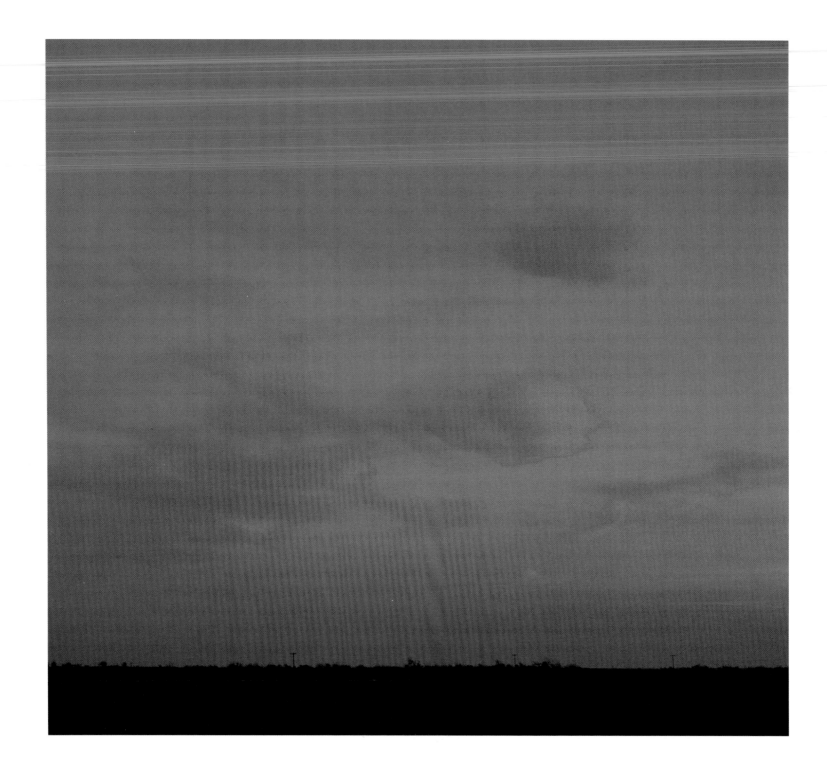

74

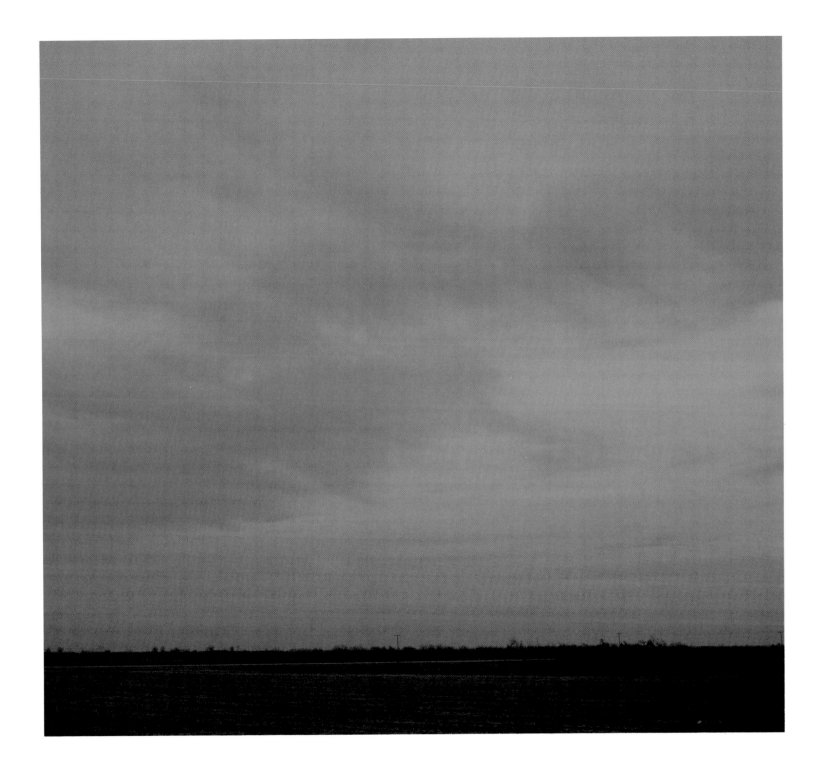

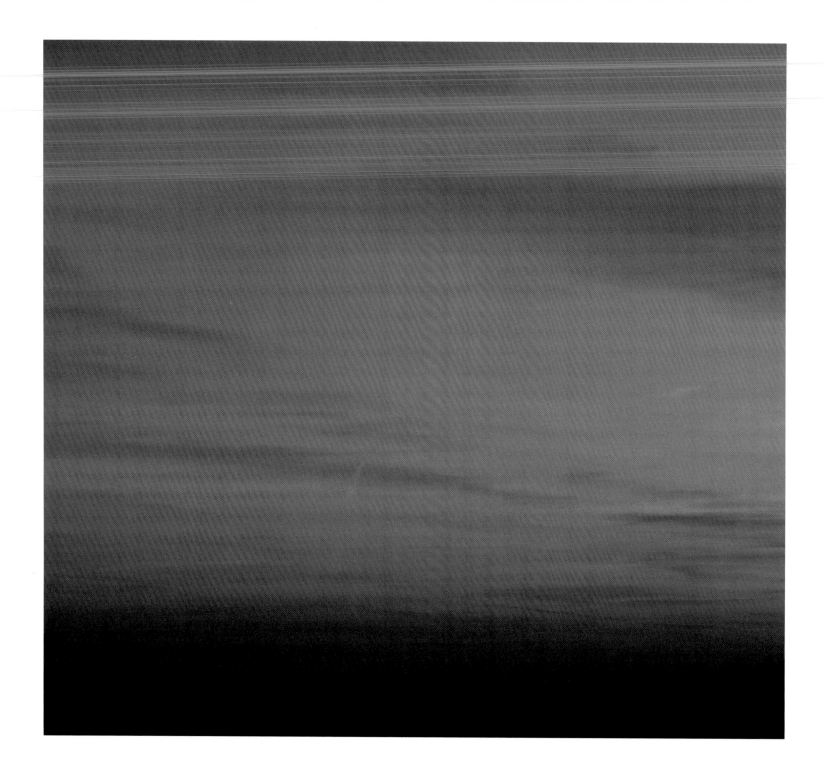

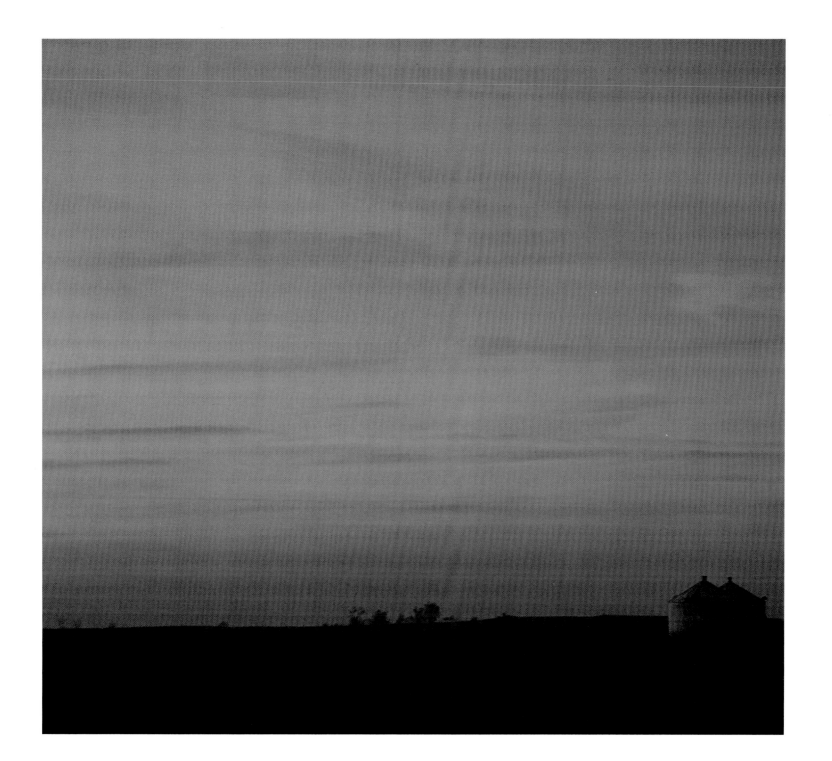

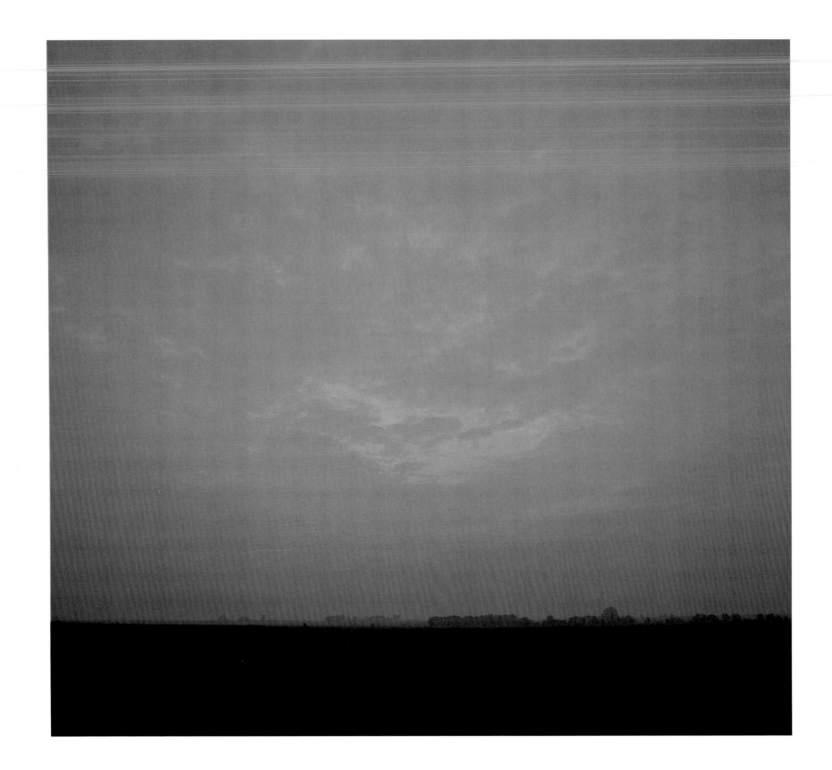

78

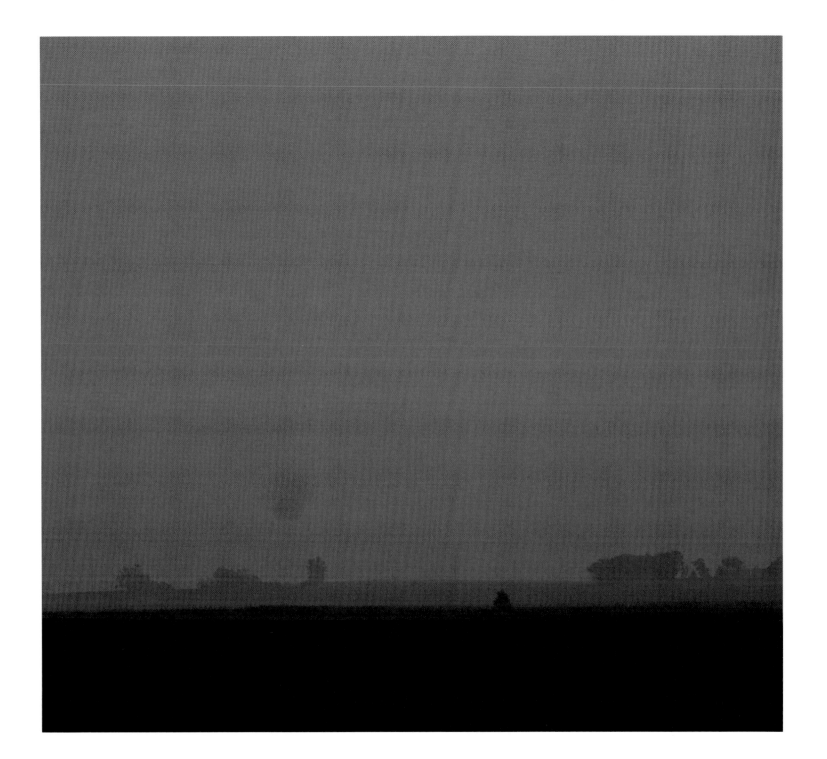

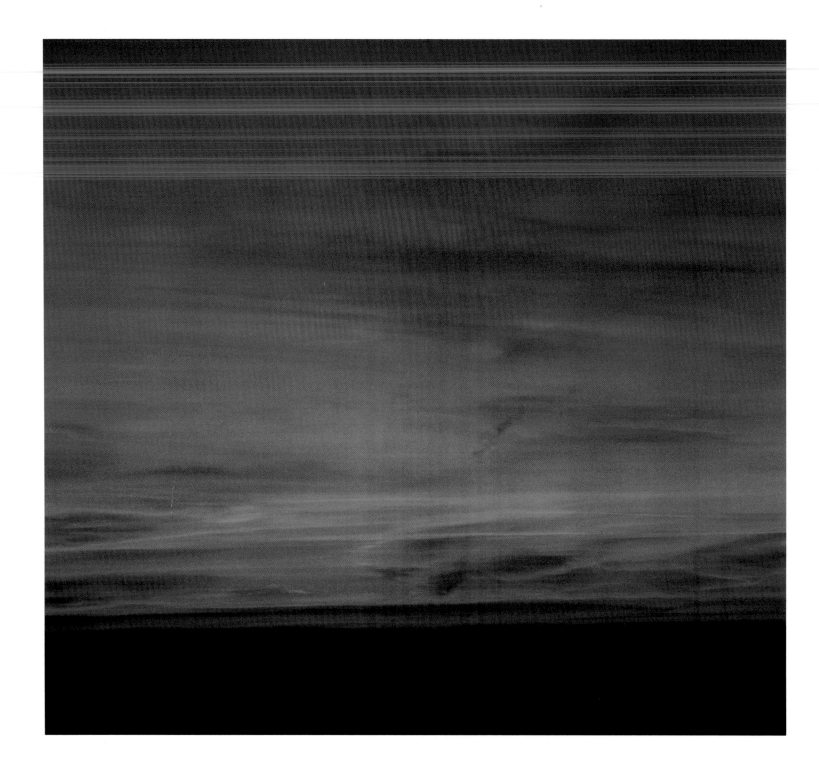

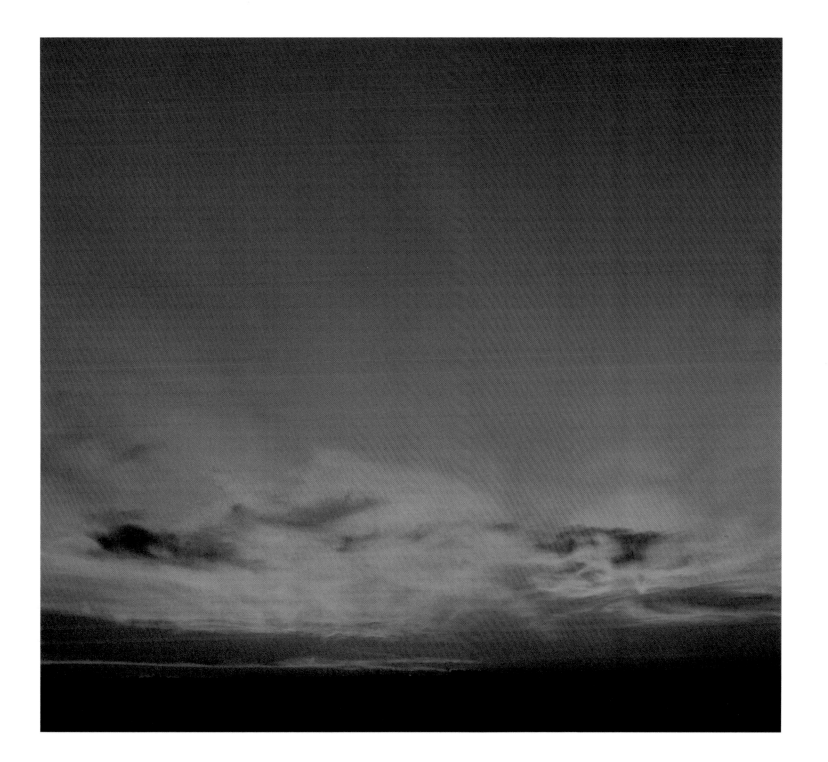

81

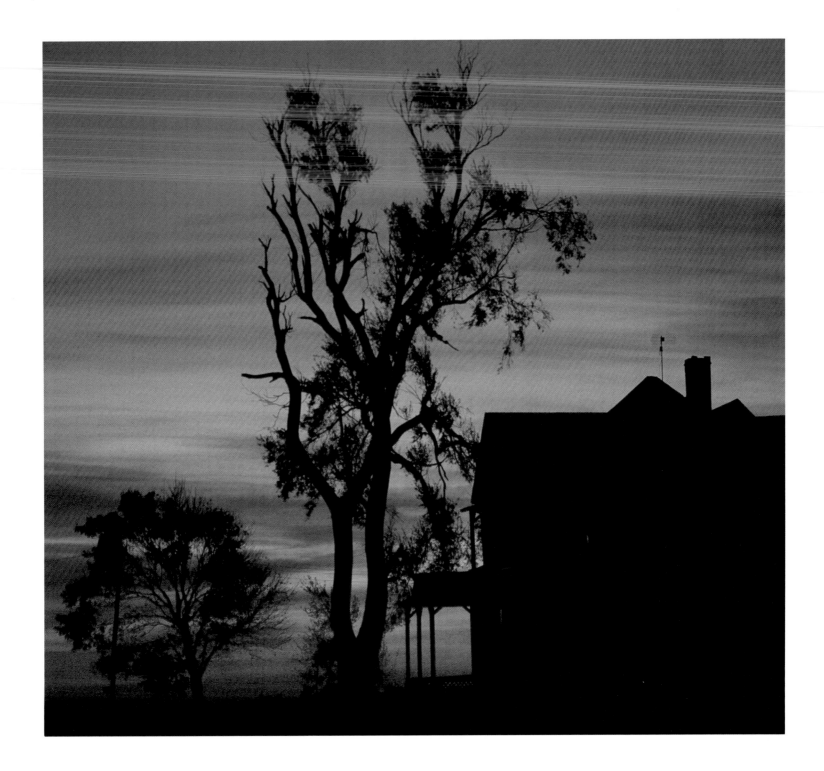

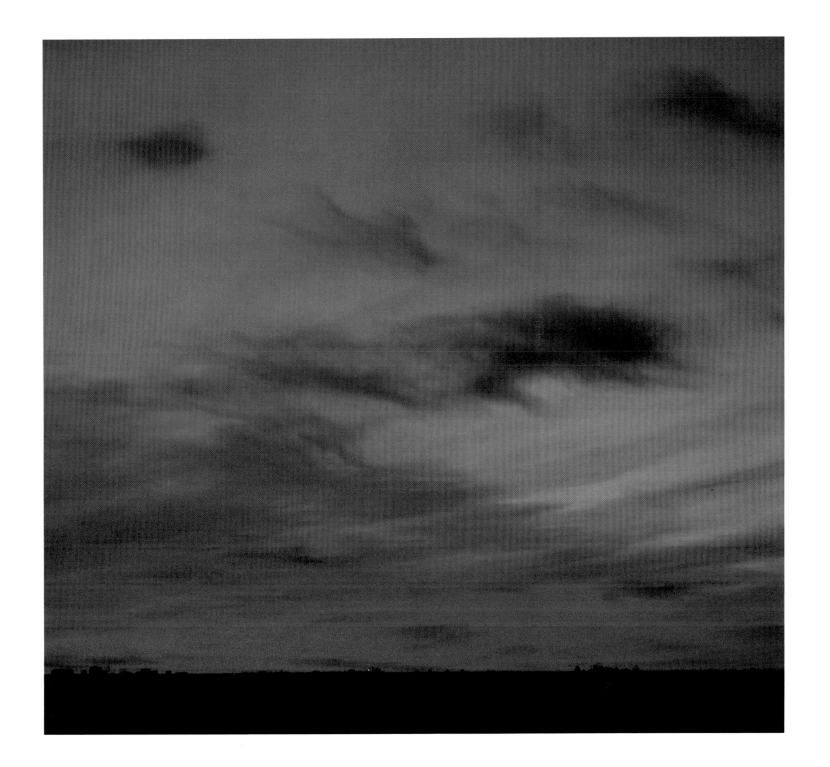

83

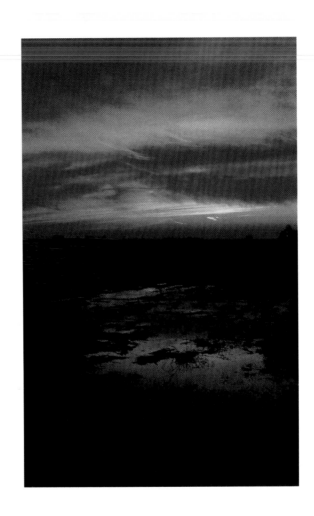

Technical Note

The two vertical photographs at the front and back of this book were made with Canon AE1 and Nikon 8008 cameras. All of the photographs forming the main body for the work were made with a Mamiya RB67 Pro S camera. 55mm, 90mm, 127mm, and 250mm lenses were used.

All but two of the transparencies were made with Fujichrome Velvia.